KAREN LAMONTE
ABSENCE ADORNED

Karen LaMonte
Absence Adorned

Museum of Glass: International Center
for Contemporary Art, Tacoma, Washington
in association with
University of Washington Press
Seattle and London

The artist thanks the Virginia A. Groot Foundation for its generous support.

This book is published in conjunction with the exhibition *Karen LaMonte: Absence Adorned*
presented at the Museum of Glass: International Center for Contemporary Art,
Tacoma, Washington, from December 10, 2005 – September 4, 2006

Printed in the Czech Republic

Design by Atelijeur Půda
Editorial review by Sigrid Asmus

Frontispiece: SEMI-RECLINING DRESS IMPRESSION (detail), 2005. 42 ½ × 27 ½ × 39 ¼ in.

First Edition

ISBN 0-9726649-1-2

Published by
Museum of Glass: International Center for Contemporary Art
1801 Dock Street
Tacoma, WA 98402-3217
United States of America
www.museumofglass.org

Distributed by
The University of Washington Press
P.O. Box 50096
Seattle, WA 98145-5096
www.washington.edu/uwpress

www.karenlamonte.com

Contents

It is with great pleasure and enthusiasm that the Museum of Glass: International Center for Contemporary Art presents *Karen LaMonte: Absence Adorned* — the artist's first solo museum show in the United States. This exhibition and accompanying catalogue celebrate the exemplary work of an artist whose star is rising.

Since her Fulbright took her to the Czech Republic in 1999, LaMonte has been refining her painstaking process to reinterpret the dress as a sculptural form and metaphorical symbol. Working at a technically superb level, the artist invests her keen examination of space and light with art history's splendid tradition of draping and adorning the human form to convey notions of prestige and wealth. Breathtakingly exquisite, LaMonte's translucent glass gowns go beyond the tremendous mastery of skill required to realize them by transforming the void with traces of human existence.

Numerous staff lent expertise to the realization of this exhibition and catalogue. On behalf of the Museum and its Board of Trustees, I would like to thank the Museum's curator, Juli Cho Bailer, for her leadership and guidance in organizing this exhibition. I am grateful for her insightful essay and deep enthusiasm for the artist's work. I extend a special thank you to Arthur C. Danto for his invaluable contribution to the book. Particular mention should also be made of the vital work of Rosanna Sharpe, director of curatorial affairs; further thanks go to Bridget Calzaretta, exhibition designer; Rebecca Engelhardt, registrar and collections manager; Liz Cepanec, visiting artists program manager; and Sigrid Asmus for her editorial review.

It has also been a pleasure to collaborate with Karen LaMonte and with Steve Polaner on all aspects of this project and we are especially grateful for the spirit and generosity of the artist, and Katya and Doug Heller of the Heller Gallery. And finally, we wish to acknowledge the Paul G. Allen Family Foundation, Click! Network, and the Art Alliance for Contemporary Glass for their generous support.

The Museum of Glass is proud to present the innovative vision of Karen LaMonte, whose work provides such rich evidence of a distinctly American exploration of social and gender issues, yet reveals a sensibility as broad and enigmatic as that of any of her European contemporaries.

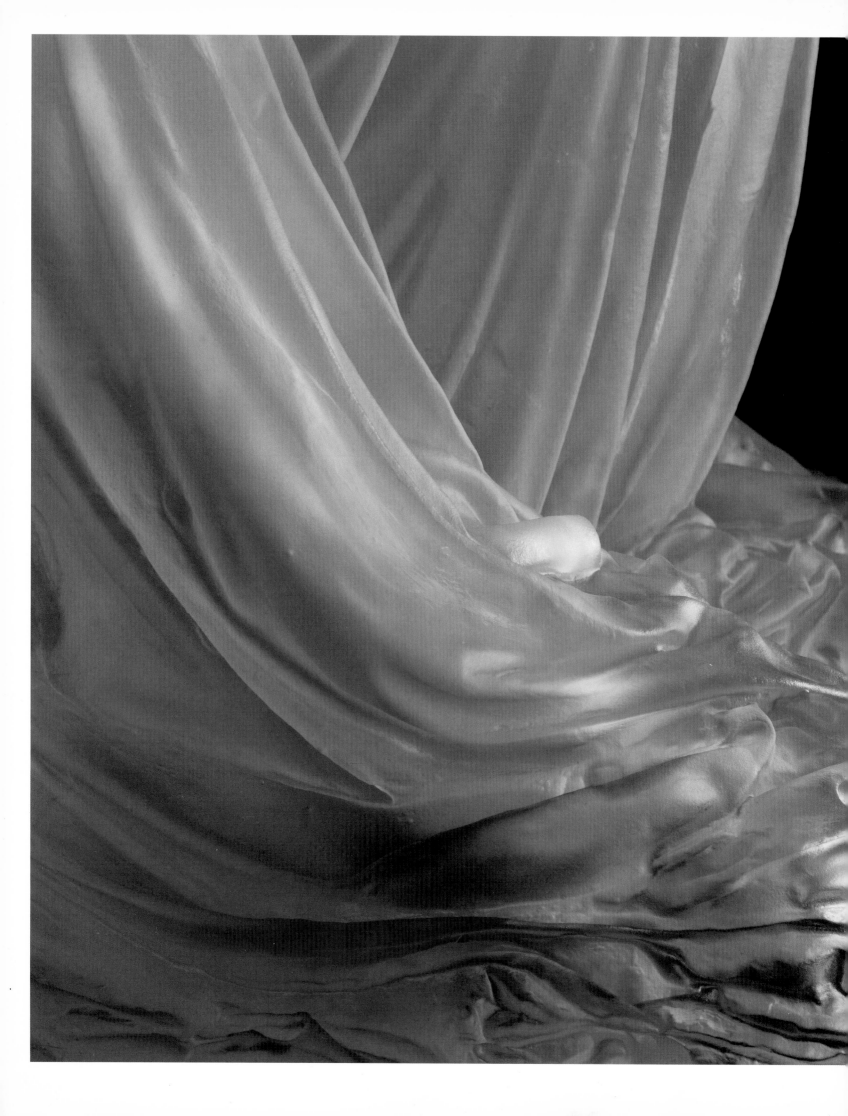

The Poetry of Meaning and Loss:
The Glass Dresses of Karen LaMonte
Arthur C. Danto

I first became fascinated with the work of Karen LaMonte when I read
an essay by her[1] on the state of glass art in one of its main centers, the
Czech Republic, where she had gone in 1999 as a Fulbright student
to study the craft of monumental cast glass. What fascinated me was
less the account she gave of artistic practices in that country than
her reason for having gone there in the first place. "I wanted to make
a life-size, hollow cast-glass dress," she wrote. "I knew the piece
would be very technically complicated and since the world-renowned
center for large-scale casting is the Czech Republic, I decided to pack
my bags and go for it." The essay explained how she realized her
project, but told the reader nothing about her reasons for wanting to
make a life-sized dress in glass. Where did such an astonishing idea
come from? I once read a somewhat similar statement by Charles
Dickens. He was explaining how, when a rising young writer, he
was offered the opportunity to write some sketches of sporting life
in England. "I thought of Pickwick," he said, "and wrote the first
chapter." "I wanted to make a life-size dress out of glass, and traveled
to the Czech Republic" has the same unselfconscious abruptness
as that. However interesting LaMonte's account of large-scale glass
casting in the Czech Republic may have been, someone else could
have written it. My interest was in the genius of her vision. Finding
out how to execute the vision was something that could be learned
in the glass-casting factory in Pelechov. The vision itself, by contrast,
was bestowed as a gift of the creative imagination, and transformed
her into a very different artist than she would have been, had the
vision not been granted her.

What is particularly engaging about LaMonte is that she
seems to have no idea how extraordinary that bestowal was. When

[1] Karen LaMonte. "Global Glass: Czech Republic." *Glass Magazine*. No. 75, Summer,
1999. pp. 46–49.

I asked her about it she told me that she was initially interested in translating fabric into glass. She had been working with puppets, she explained, and had the idea of making them into glass objects. She had made some small garments out of glass, but they looked like doll-clothes. So she had to make them larger. Why a dress? Well, she said, I'm a girl, so I naturally thought about a dress. But a dress is a pretty shapeless garment unless there is a body in it. So one thing led to another, and in the end what she wanted was a life-sized glass dress contoured to express the shape of a woman's body. But glass on that scale had better be cast, and since that technique is practiced best in the Czech Republic, voilà! That was her account, more or less, and perhaps one might have gotten the same step-by-step chronicle of how Pickwick materialized in his imagination from Charles Dickens, had anyone pressed him. Perhaps that is how it always is with historical explanations — one thing happens and then another. And all at once we have the Renaissance or the French Revolution. The longest journey, the Chinese say, begins with a single step. "Before tackling the adult size," LaMonte says matter-of-factly, "I started with a child's dress." Her first monumental casting of a woman's dress was called *Vestige* (2000).

Now I have seen LaMonte's glass puppets, as well as the effigies of clothing in works of hers called *Clothlines*. These are engaging, witty pieces in blown glass, but they are certainly not monumental. They are in their nature ornamental, as blown-glass work often is. One would never, on the basis of these earlier works, have been able to visualize a work as beautiful and as powerful as *Vestige*. It would, to use a somewhat forced metaphor, be like visualizing a rose on the basis of examining some rose seeds. Or visualizing a butterfly by studying a cocoon. Nothing like *Vestige* had ever been done, so far as I am aware. It would have been fascinating to read an account of how, as LaMonte puts it, "The dress had been translated in perfect detail into glass." Think of how exciting it is to read the account in the *Autobiography* of Benvenuto Cellini of the casting of his great *Perseus*. But that still leaves the provenance of LaMonte's great idea, of a life-sized dress made of glass, unaccounted for. That vision must already

have been formed in her imagination while she set about applying for a fellowship that would take her to the Czech Republic, and which guided her steps once she was there. In an essay on her Fulbright experience, she writes, "I have found that it is possible to cast the pieces I want on the scale I need to, but more importantly, that using the techniques I have learned, I can successfully communicate my ideas using cast glass as a medium." But before that could happen, she had to do something even more remarkable — to "introduce my dress project to [Zdeněk] Lhotský, since it differs so greatly from Czech glass." Lhotský, she tells us "was excited by the idea itself and enthusiastic about the challenge of making so complicated a piece." But beyond the technical challenge, to appropriate a phrase from Shakespeare, of giving "an airy nothing a local habitation and a name," I must suppose that Lhotský, like me, was charmed by the poetry of translating into the magic of glass the fluttering lightness of a garment like the one that became *Vestige*. After all, a woman who fills the garment that became *Vestige* herself must become a vision of enhanced beauty:

> Whenas in silks my Julia goes,
> Then, then, methinks, how sweetly flows
> That liquefaction of her clothes!
>
> Next, when I cast mine eyes and see
> That brave vibration each way free,
> — O how that glittering taketh me!

Vestige freezes, so to speak, the enchantment the garment is intended to confer upon its wearer.

"Clothing," LaMonte writes, "both protects and projects. It is armor and costume, plumage and camouflage." That is true, but too sweeping. It is true of the padded garments of the Maoist welder, the bib-overalls of a farm worker, the oilskins of a lobsterman. The vision LaMonte carried with her was of femininity embodied, a garment constructed to project and enhance the grace of its wearer, clinging

and diaphanous. The relationship is reciprocal: the wearer gives life to the garment, like Julia in Robert Herrick's poem. *Vestige* has a tiered skirt, a high neck, long sleeves, and, as the artist likes to say, "a bow on the butt." It does not hang slackly, like a dress on a hanger, it implies limbs, joints, curves. It is inseparable from the enfleshed person within. But it is also co-implicated with the circumstances in which it is appropriately worn. It is worn on and as part of special occasions, under which the wearer is making a statement about herself. It is not a dress in which one does chores or runs errands, it rejects everydayness. It goes with candlelight and music, sweeping staircases and jewelry, flowers and wine. It confers in the language of garments preciousness and beauty on the person it presents to the company in which it belongs. Its wearer is a fairy-tale princess, a bearer of happiness in the way she moves through the space of the ball. It is encapsulated in life the way a dream is. And this I think is true of most of the dresses LaMonte cast in glass after *Vestige*, which, as a title, is evocative in its own right. A vestige is what remains of something that no longer exists. So it is a tangible memory of all that the dress itself stands for, including, perhaps, the body of she whose dress it was. The translucence of glass lends a certain ghostliness to the object, which accounts for half its poetry. It is more than a piece of second-hand clothing, something found on a rack, since it is still filled with what appears to be a living body, bereft, as it happens, of head and extremities. That must, in a sense, be an illusion. So it is a vestige the way a memory is, something that is carried away after the event to which the dress belonged when it was worn. It is evocative the way an old photograph is. So when we see what materialized in the Czech Republic, we begin to realize something of the content of LaMonte's vision. It was a lot more than "a life-size dress cast in glass."

The dress as a sculptural form in its own right cannot easily have been imagined much before the 1960s, when artists took on the project of overcoming the gap between art and life and began to make art out of ordinary objects, in part because of their rich human associations. A good example is Judith Shea's 1980 *Inaugural Ball*, which greatly impressed me when I first saw it in an important exhibition of women's art, *Making Their Mark: Women Artists Enter the Mainstream, 1970–1985*.[2] It was a life-sized dress, simply shaped, and hung on the gallery wall, and though it was presented as a work of art, nothing obviously distinguished it from a woman's dress as such. In that show, there were some works by Miriam Shapiro, which she called *Femmages*, assembled from articles sewn and embroidered by women — doilies, tablecloths, and aprons — which Shapiro, for ideological reasons, intended to celebrate. They were in effect collages made out of pieces of fancy stitching. By contrast, Shea's work was displayed as such, like a ready-made, which it could have been.

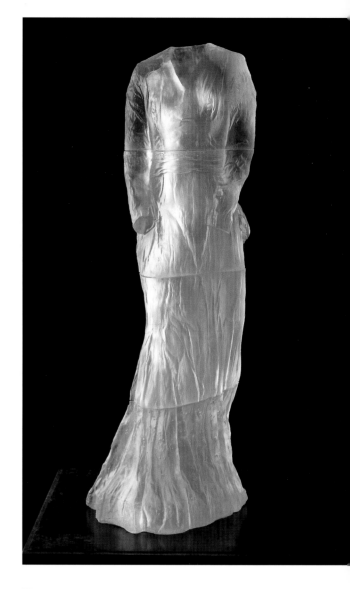

VESTIGE, 2000
cast glass, 60 × 40 × 30 in.
Photographer: Gabriel Urbánek

[2] Catherine C. Brawer and Randy Rosen, editors. *Making Their Mark: Women Artists Enter the Mainstream, 1970–1985*. Cincinnati: Cincinnati Art Museum; New York: Abbeville Press, 1989.

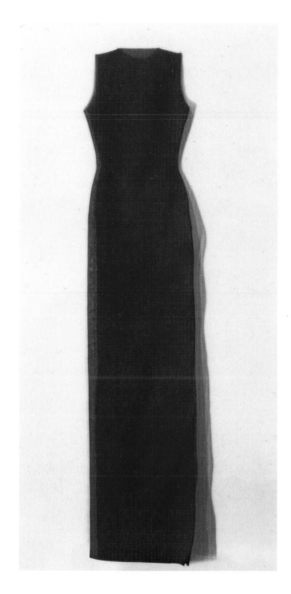

INAGURAL BALL, 1980
Judith Shea (American, born 1948)
Cotton organdy, 67 × 24 × 1½ in.
Courtesy of the Whitney Museum of
American Art, New York
Photograph by Sandak, Inc.

The seventies were a time when painting, as a medium, was under attack: feminists had raised political questions about painting, based on the lingering *machismo* with which the medium was associated since Abstract Expressionist times, in an atmosphere in which the question of why there were no great women painters had become the topic of intense debate. It was a time when it was of some importance for women artists to find ways of making an art that spoke to women as women, and although there were paintings by women in the show, it seemed clear that its organizers were anxious to show alternative modes of expression that women artists had found. Almost nothing spoke to differences in gender the way articles of clothing do. Shea's work looked like a dress that might be found in any woman's closet, so that, like a ready-made work, it raised the philosophical question of what made the difference between it and a mere garment. If a snow shovel or a bottle rack could be a work of art, why not an evening gown? In any case, it would not ordinarily have occurred to a male artist to see the dress as a ready-made — though of course Marcel Duchamp cultivated a feminine identity as Rrose Selavy. In fact, Judith Shea did the cutting and sewing, and there is, if one looks at it with some detachment, a certain aesthetic austerity in its lines: Shea had a certain commitment to Minimalist principles as a sculptor. Still, it would have required a great deal of sexual confidence for a male minimalist to have exhibited a pink evening dress made out of cotton organdy. So there was an element of provocation in showing it as an example of Minimalist art on Shea's part. *Inaugural Ball*, in any case, was a highly overdetermined artwork, through which Judith Shea was able to raise a large number of issues in aesthetic politics all at the same time.

I am not confident that anything like this was true of *Vestige*, made two decades later. It is difficult to believe that it was conceived of in a polemical spirit at all. For one thing, there was a tradition in glass art of making large objects, like pieces of furniture, out of glass. The Baccarat Museum in Paris displays glass thrones and the like, though most of them seem to me to have been occasions more for demonstrating virtuosity than anything else, and none had the depth of meaning one responds to in LaMonte's glass dresses. Nevertheless, *Vestige* almost certainly raises questions that bear on the issues of gender that defined the art world of the nineties, which can be brought out by comparing LaMonte's work with that of her contemporary, Howard Ben Tré, who also worked in cast glass on a monumental scale, but whose work seems almost flagrantly masculinist alongside LaMonte's. Ben Tré's signature forms are large uninflected monoliths, cast in American factories that produce industrial glass. They are powerful and proletarian, and one can imagine them as subject to mass production for large-scale structural projects. They project brute strength. LaMonte's pieces, whatever their weight, proclaim beauty and evanescence, fragility

and delicacy, transparency and light, luxury and magic. There is a logic in a fairy godmother's decision to underscore her protégée's femininity by fitting her out with glass slippers. A girl who can dance in glass slippers must be as airy as a song! I admire both artists greatly. I juxtapose them solely to dramatize the difference in their imagination. What interests me is the way that Ben Tré's monoliths imply their industrial provenance, whereas LaMonte's somehow transcend the circumstances of their manufacture. They leave behind the heavy labor that Ben Tré's work celebrates as part of its meaning, even if, in her case, they are part of her works' history.

This difference is almost certainly a consequence of LaMonte's decision to make the dress her central motif, and of the kind of dress she chose for transubstantiation into glass, where the fragility of the glass augments the fineness and translucency of the fabric, as well as the lightness expressed by ornamentation of the garment — flounces, bows, ribbons, ruffles. At least initially, the dresses she chose were declarations of radical femininity on the part of their wearers — garments so constructed as to project an image of ideal grace. In her brilliant book, *Seeing through Clothes*, Anne Hollander argues that "the primary function of Western dress is to contribute to the making of a self-conscious image, an image linked to all other imaginative and idealized visualizations of the human body."[3] The garments LaMonte worked with were not, except from a cynical perspective, working clothes — housedresses, business suits, uniforms. They were ornamental garments for special occasions, and they translated into visual terms the metaphor of the woman as herself an ornament, whose substance was aesthetic through and through. There is a language of clothing that itself belongs to the discourse of gender. Since the 1970s, gender has become a subject of intense examination, in art and in life, and there is a wide understanding that there is, as with language, a large element of social convention in the rules through which it is governed. That has been taken to mean that, in principle at least, the rules can be changed and that the roles that have governed women's lives and the way women are represented in society are not inalterable. And in particular that the forms of beauty are themselves not immutable: the full-figured beauties of Lorenzo Lotto mark one extreme, the sleek, almost metallic slenderness of Tamara de Lempicka mark another. Lotto's women embody a dynastic role in that they are expected to furnish heirs. Lempicka's women dress to express their independence: airplanes and fast cars are their fashion accessories. Gender differences may not be genetically inscribed, but the degree to which they can be altered at will is limited. Nevertheless, they do change with the times, which is the chief deep difference between gender and sex. The clothes women wear define their moment in history.

"I create clothing in glass," LaMonte wrote, "to represent animated yet absent beings, a human form without a body." Most

[3] Anne Hollander. *Seeing Through Clothes*. Berkeley: University of California Press, 1993. p. xiv.

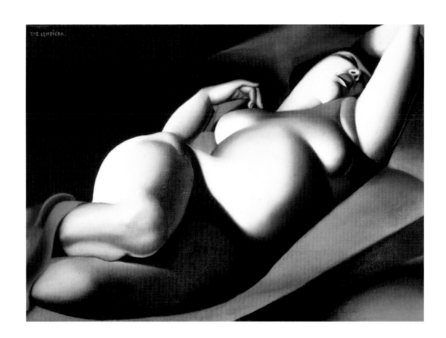

of the dresses that LaMonte has cast in glass are as much vestiges
of a vanished time as of an absent person. They are as dated as old
photographs, found in the backs of drawers or forgotten between
the pages of books. This brings me to one of the most interesting
features of LaMonte's work. We can see through the fabric to the
naked body of the women who wore it, as if the body left its imprint
on the dress that concealed but alluded to it. It is as if the beauty
of the wearer's body were preserved in her garment, and we see
the navel, the nipples, the shadowed delta between her legs, her
buttocks. Critics I have spoken with have deplored this as gratuitous
eroticism, but I see it as adding a dimension of tragedy to the poetry
of the work. The dress belonged to a moment when the wearer was, to
use an expression of Proust's, *en fleur.* The dress belonged to a certain
moment of history, which it preserves — it shows how women dressed
for certain occasions at a certain moment. The wearer will have
aged. She looked like that then, but, if she is still alive, it is certain
she will not look that way now. There is a double melancholy — the
melancholy of fashion, and the melancholy of bodily change, from
nubility to decrepitude. The breasts have fallen, the waist thickened,
the skin has lost it transparency and luminescence. The poignancy
of LaMonte's dresses is a product of two modes of change in which
we participate as human beings, composed, as we are, of flesh and
meaning. Their poetry is the poetry of beauty and loss.

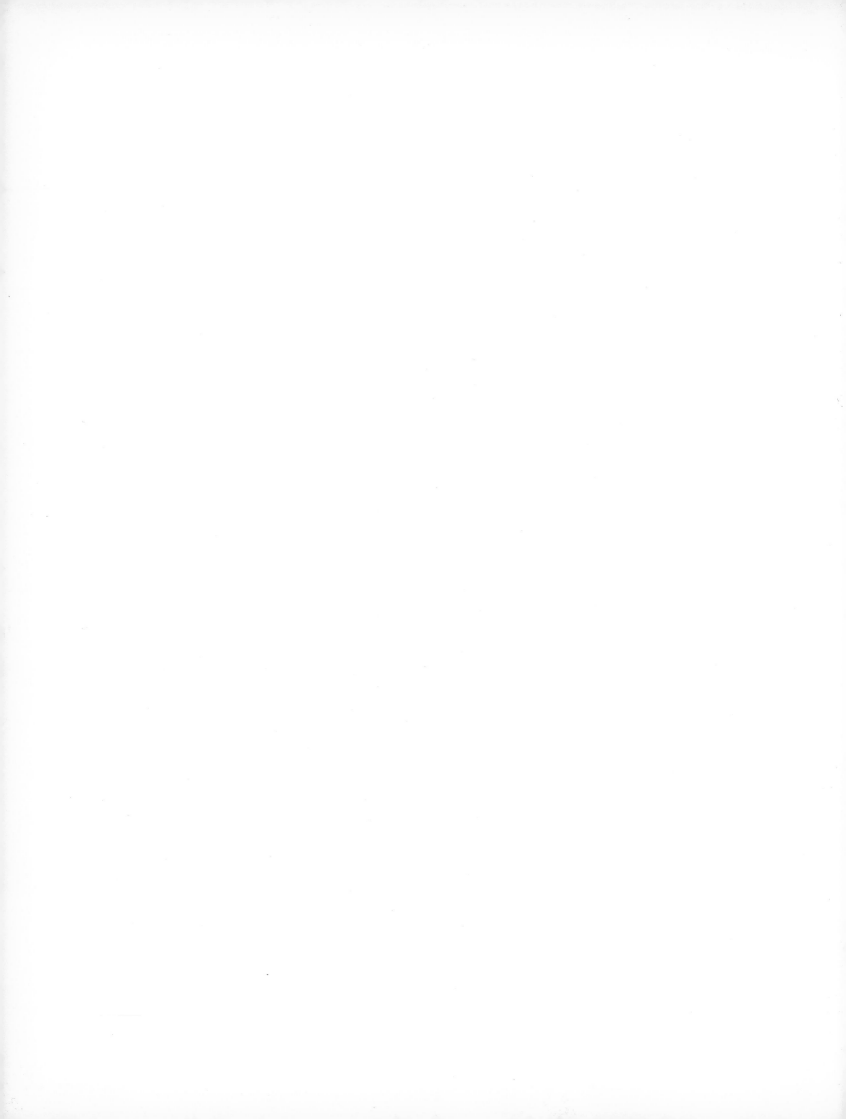

KAREN LaMONTE: ABSENCE ADORNED

JULI CHO BAILER, CURATOR
MUSEUM OF GLASS: INTERNATIONAL CENTER FOR CONTEMPORARY ART

To see Karen LaMonte in her studio amid wax figures, cast-glass sculptures and garments, an iron and pins, is to begin to comprehend how intrinsically her work is concerned with the intersection of many traditions — of art history, fashion, and theater — ultimately converging in a dazzling display of exquisite glass gowns and haunting mirrors.

For LaMonte, the preparation of wax models and fabric leading up to the final casting in glass shares equal importance with the foundry work itself. In this way, LaMonte reminds me of the legendary French couturier Madame Grès, who reportedly used up to seventy meters of silk to create a single Classically inspired evening gown. Where Grès ardently fashioned her toile directly onto living models, LaMonte scrupulously drapes and pins garments, sashes, and shawls onto the body molds she creates to form the shapely interior for each of her translucent glass dresses, offering peek-a-boo nudes. Clearly, LaMonte is attracted to the qualities of crystalline glass, yet what is perhaps even more fascinating for her are the qualities of fabric and the brilliant legacy of its treatment in art history and fashion.

LaMonte has used her highly developed art of lost-wax glass casting since the late 1990s. In her earlier works, the dresses were allowed to cascade naturally from the figure with little manipulation. Her most recent pieces, however, represent a pivotal shift in approach as both her mastery of draping and her casting technique impart added emotion and vitality to her work. The effect recalls the voluptuous layers of seemingly diaphanous folds used by Hellenistic sculptors to accentuate the sensuality of the body, strategically concealing and exposing the body and inescapably influencing our notions of female beauty and modesty. LaMonte's reinterpretation of the dress and her methods for incorporating historical references can be understood within a continuum of myriad practices for rendering textiles in art. Extending from Classical times, generations

of artists have created a codified structure for representing and viewing the clothed figure, one that pervades our current views about the power of clothing to ennoble, idealize, and conceal the wearer. Building her work around her keen understanding of our inherited appreciation for clothing, LaMonte openly admits to mining art and fashion history in search of the most superb and iconic examples of these traditions.

As she deepened her investigation of costume and fabric beyond its role as an emblem of wealth and luxury, Gian Lorenzo Bernini's Baroque masterpiece, *Ecstasy of Saint Theresa* (1645–1652, Santa Maria della Vittoria, Rome), became a significant inspiration. Bernini's bold sculpting of folds forms a crescendo that for LaMonte amplifies the erotic intensity of the saint's swooning desire for a divine union with God. Through a similar probing into the way cloth holds the capacity to represent and express intensity, LaMonte is bringing an added maturity to her earlier headless and limbless women — pristine, yet somehow lifeless in their still perfection. Her achievement can be seen in her newest generation of models, cast from women of varying ages, and now taken beyond their original upright and pert selves to evoke a widening spectrum of emotions as they languish solemnly or recline seductively like odalisques.

Less interested in contemporary garments than in historical costume, LaMonte has spent a great deal of time mulling over and questioning the relationship between clothing and women in art and theater, arenas of the gaze. In *Ways of Seeing*, John Berger writes, "Men act and women appear. Men look at women. Women watch themselves being looked at. This determines not only most relations between men and women but also the relation of women to themselves. The surveyor of woman in herself is male: the surveyed female. Thus she turns herself into an object — and most

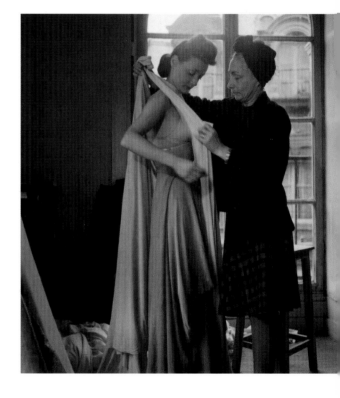

Atelier of Madame Grès at the Place Vendôme in Paris, circa 1938
Photo by Robert Schall

particularly an object of vision: a sight."[1] LaMonte seems to make this observation visible as she explores themes of female identity and fashion in her work. The alluring translucency of her glass dresses draws us into the realm of desire and voyeurism — her figures are adorned, yet have a dual appeal, both erotic and eerie, as nudes. Clothing, our "second or social skin," as the artist puts it, protects us and creates a defining boundary between intimate and public space. Fashion, however, with its conventions and pervasive influence, trusses us up into our gender and class, masking woman's unique identity and often making her invisible.

In her work, LaMonte is clearly an artist who has inherited the achievements of the feminist art of the 1970s, yet she confidently explores these conceptions of female identity and beauty without the need to critique feminine stereotypes. Undeniably sensual and beautiful, her gleaming, radiant gowns project ideals of appearance and wealth promoted by haute couture and historical portraiture, while also questioning the psychological and social implications of the way we dress. Thus, her works directly address our culture of vanity, where the dress defines the wearer and the mirror tells us who we are, and how we fall short of the stylized perfection of images in the media. Who can forget the lines spoken by the queen in the Brothers Grimm fairy tale *Little Snow White*?

> Mirror, mirror, on the wall,
> Who in this land is fairest of all?

Indeed it was the queen and not humble Snow White who lived with that decadent object, the mirror. Once found only in wealthy homes, an elaborately ornamented mirror was a luxury item, something still very true today, just as the value of period picture frames can be higher than the paintings they hold. Historically, the mirror has a solid place in pictorial works as a *vanitas* symbol — a reality check of our own mortality and an irksome reminder of the inevitability of aging. Often depicted in art to caution us to lead a pious life free of pride and lust, a spotless mirror in the context of a betrothal portrait was also understood to symbolize purity and virginity.

Inspired by such historical symbolism, and by memento images of the deceased on gravestones, LaMonte's intimately scaled *Sleeping Mirrors* and *Lark Mirrors* were created using a special photo-resist process to sandblast the portraits onto cast glass. Meant to be installed in a dimly lit room where the faces can emerge from darkness as though out of a hazy slumber, the mirrors evoke archetypal themes of death and drama. Curiously, some of the mirrors reflect the image of a clown. By juxtaposing human expressions and the painted face of a clown, an outlandish performer who is human and yet not quite human, the artist invests her carefully crafted theater with a sense of artificiality. Circulating

[1] John Berger. *Ways of Seeing*. London: British Broadcasting Corporation; Harmondsworth: Penguin, 1995, p. 41; original publication 1972.

between history and illusion, LaMonte's work allows the artist's and our own private anxieties about life and death (presence and absence) to commingle with romantic and elegiac beauty.

Delving into illusory space, LaMonte's imprinting of the invisible speaks to something greater than the limits of our physical self. In her glass dresses, only a few traces of the original figure are carried forward — the curve of a breast, the slope of a back, the indentation of a navel — the dress and imprint of the body are one. And although the life-size scale of her dresses creates an experience of looking at something familiar, their stark colorlessness imparts the sense of a presence physically larger and more significant, inhabiting a space in which time is evocatively suspended. Perhaps it is the expression of this frozen moment that makes the work seem monumental. In their ghostly, translucent forms, there is something of a reminder of the ephemeral quality of our corporeal selves and the fragility of the human condition. By transforming negative space into undulations of curves that allude to both the beauty and evanescence of life, LaMonte does not simply bestow presence on an absence — she adorns it.

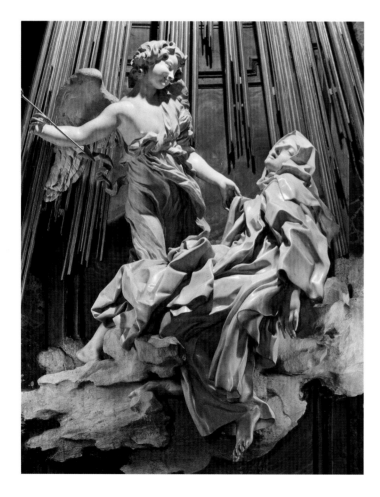

ECSTASY OF SAINT THERESA, 1647-1652
Gian Lorenzo Bernini (Italian, 1598–1680)
Cornaro Chapel, S. Maria della Vittoria, Rome, Italy, Marble, 11½ feet (height)
Photo courtesy of Scala / Art Resource, New York. ART5062

ABSENCE ADORNED

RECLINING DRESS IMPRESSION, 2005. 20 × 63½ × 15¾ in.

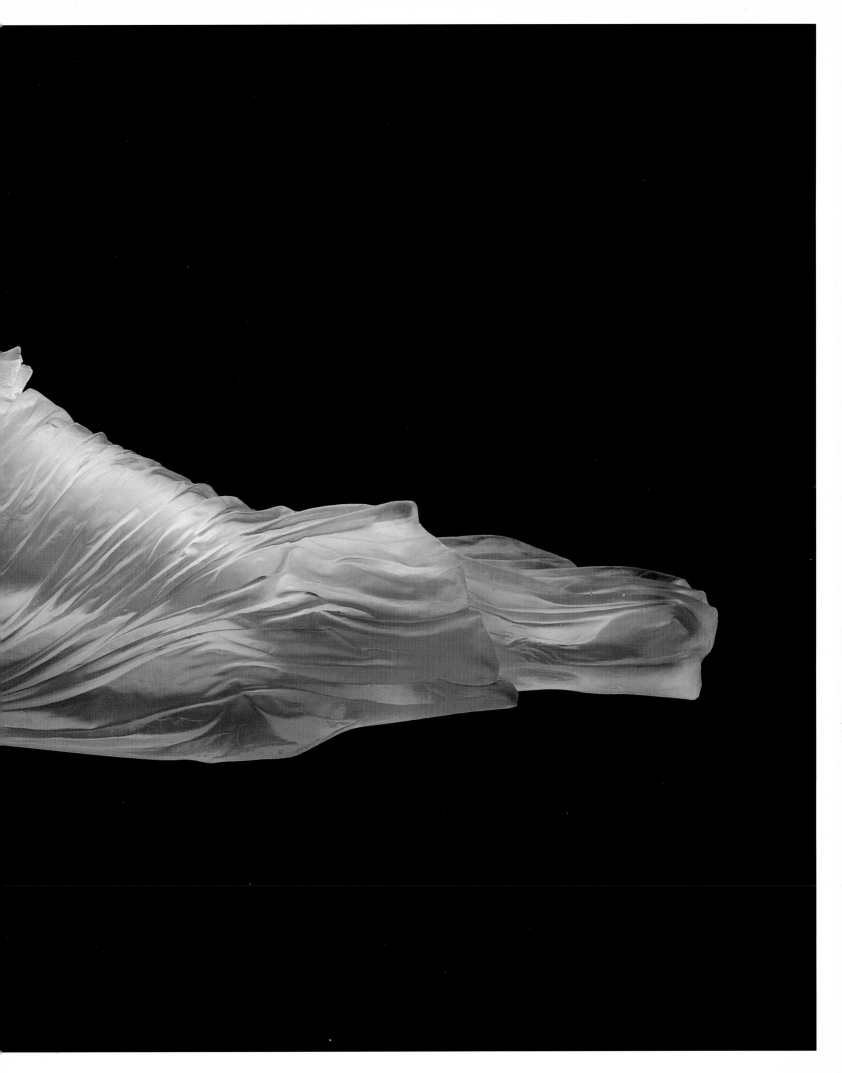

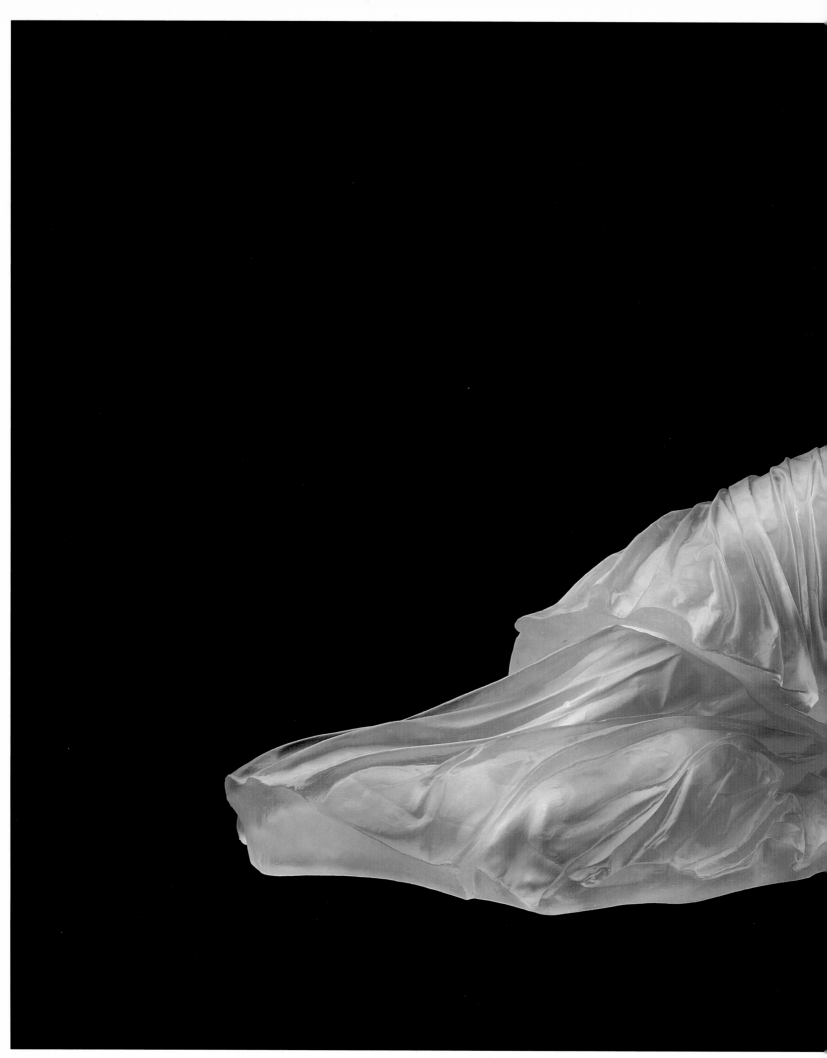

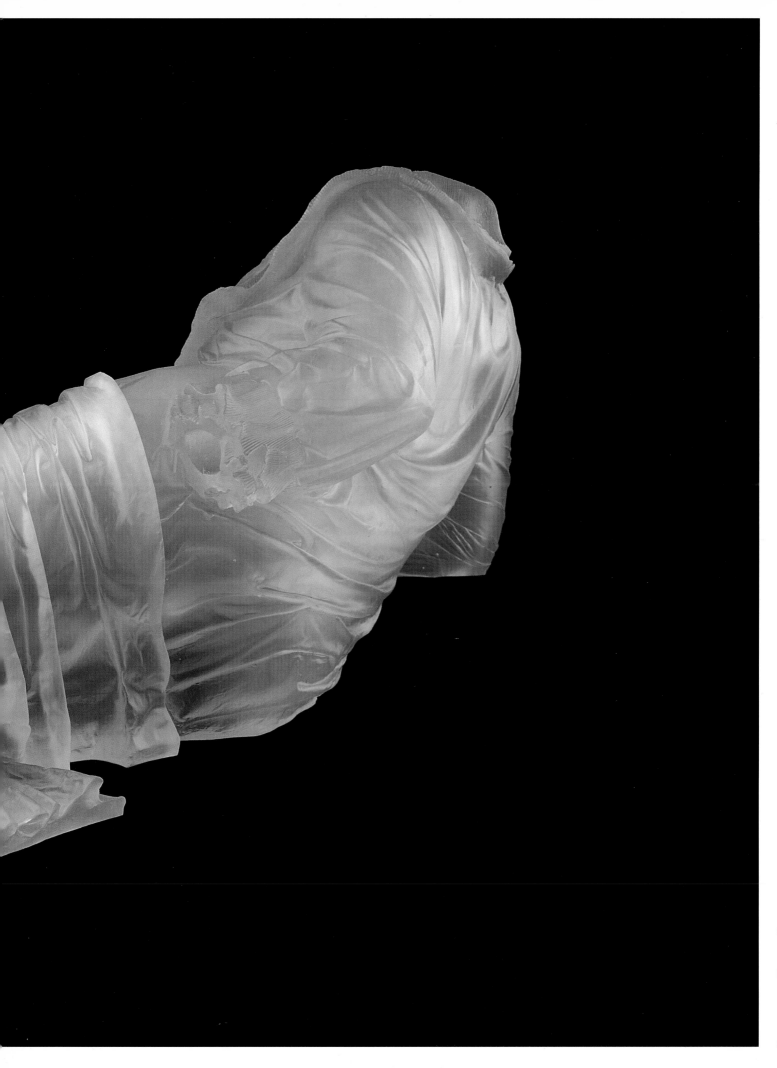

RECLINING DRESS IMPRESSION, 2005. 20 × 63 ¼ × 15 ¾ in.

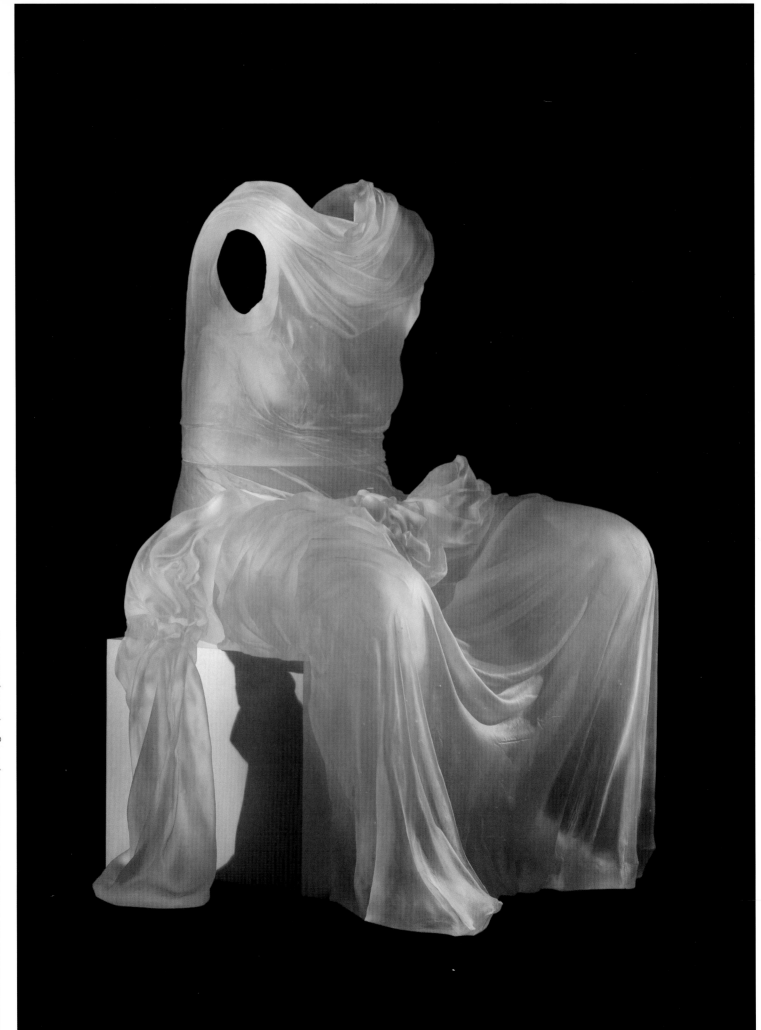

SEATED DRESS IMPRESSION WITH DRAPERY, 2005. 48¼ × 29½ × 26¾ in.

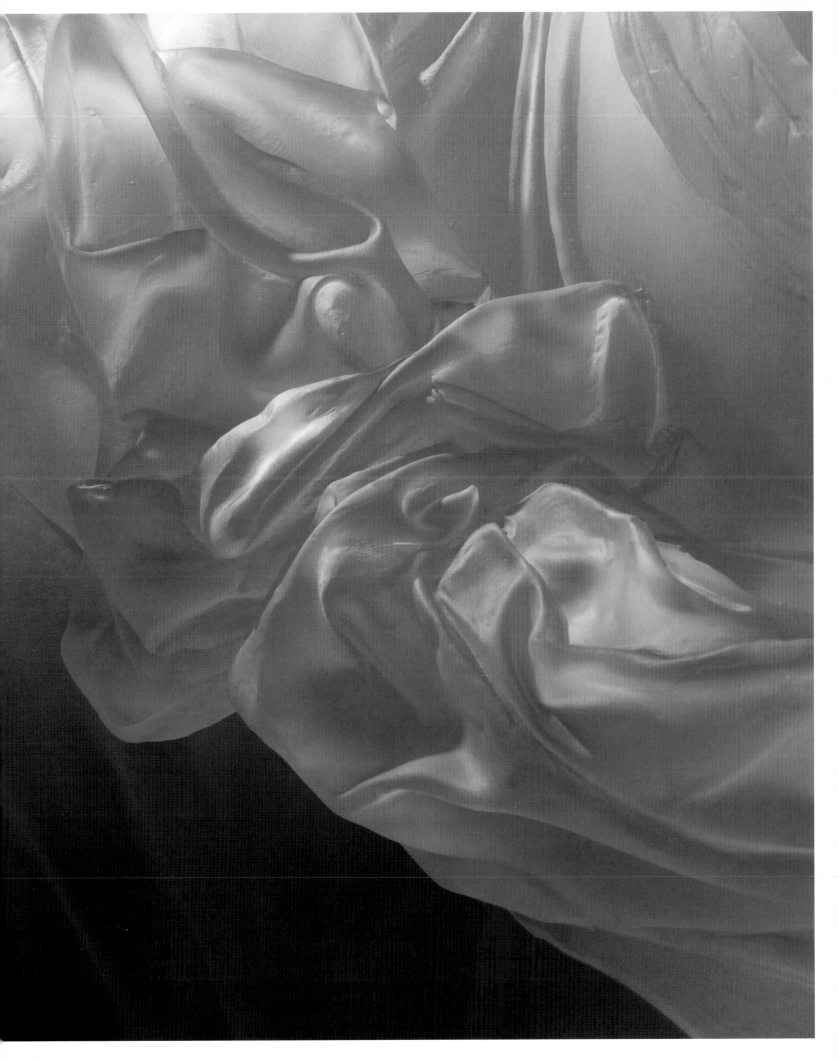

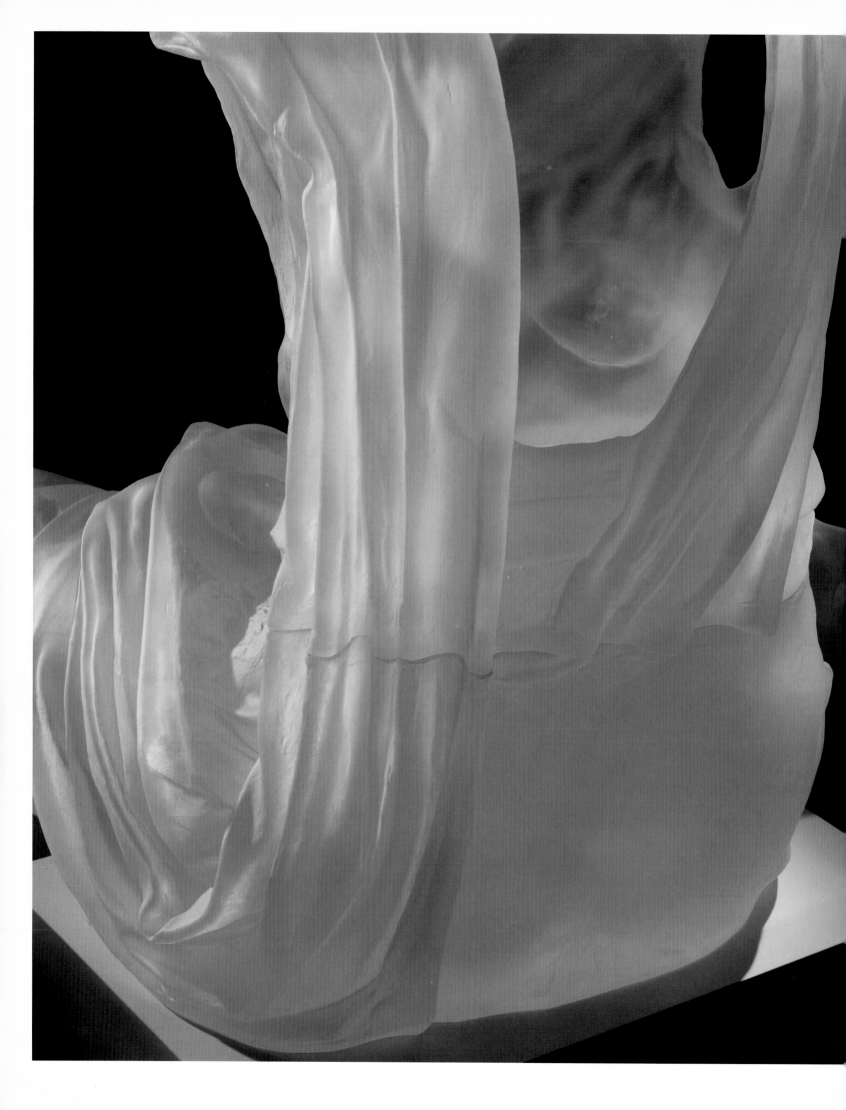

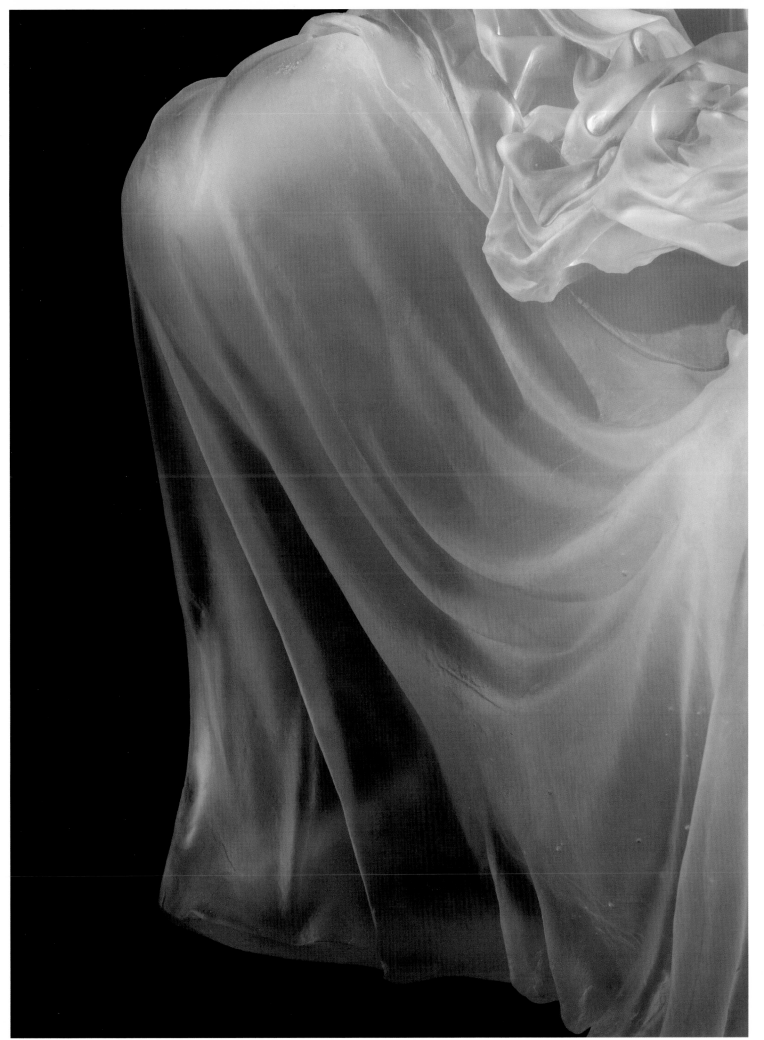

SEATED DRESS IMPRESSION WITH DRAPERY, 2005. $48\frac{1}{4} \times 29\frac{1}{2} \times 26\frac{3}{4}$ in.

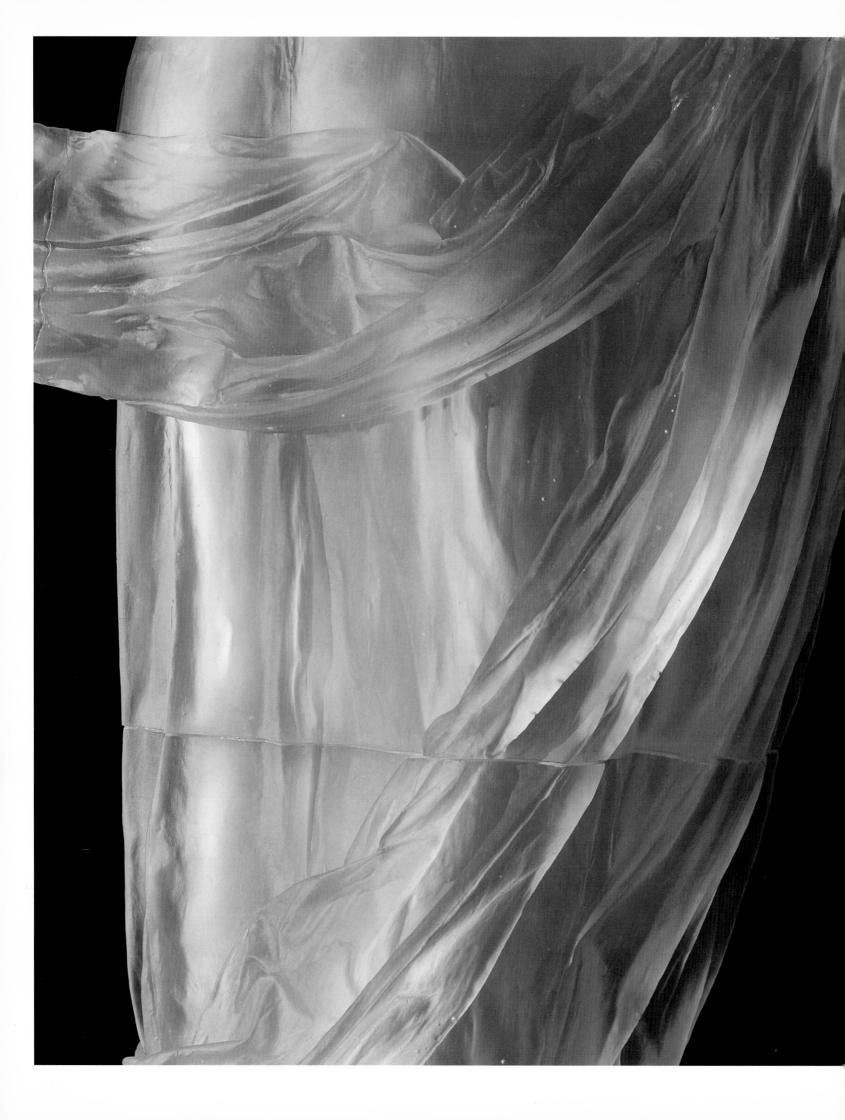

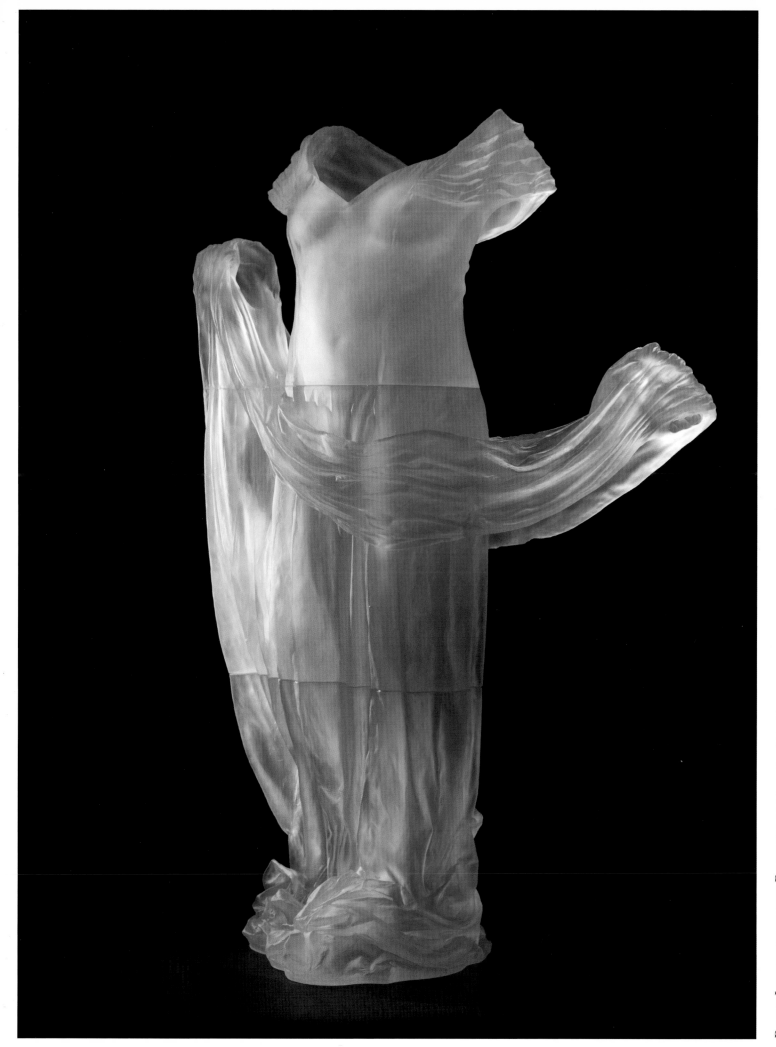

DRESS IMPRESSION WITH DRAPERY, 2005. 55 × 37¾ × 17¼ in.

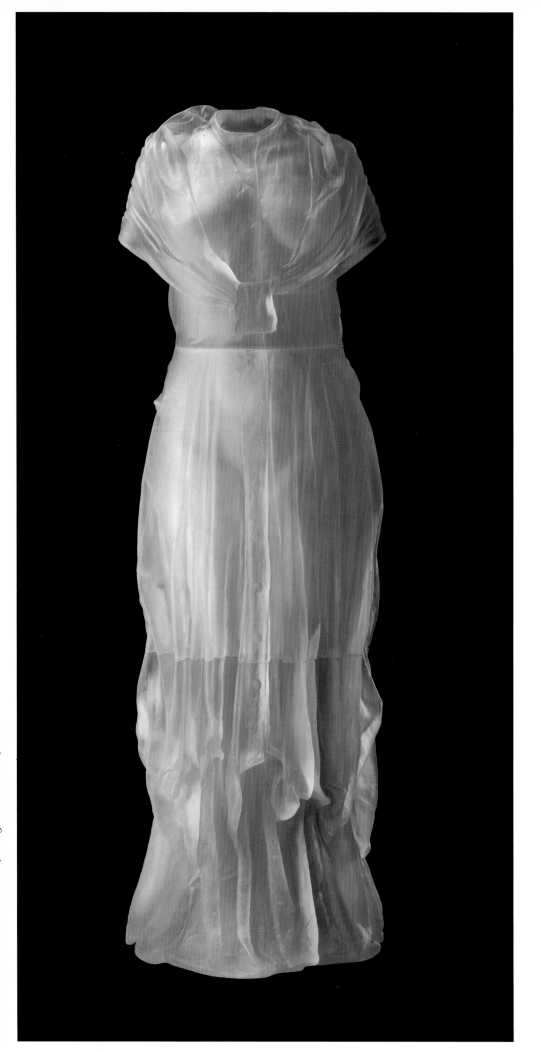

PIANIST'S DRESS IMPRESSION, 2005. 21 ¼ × 61 ½ × 19 ¾ in.

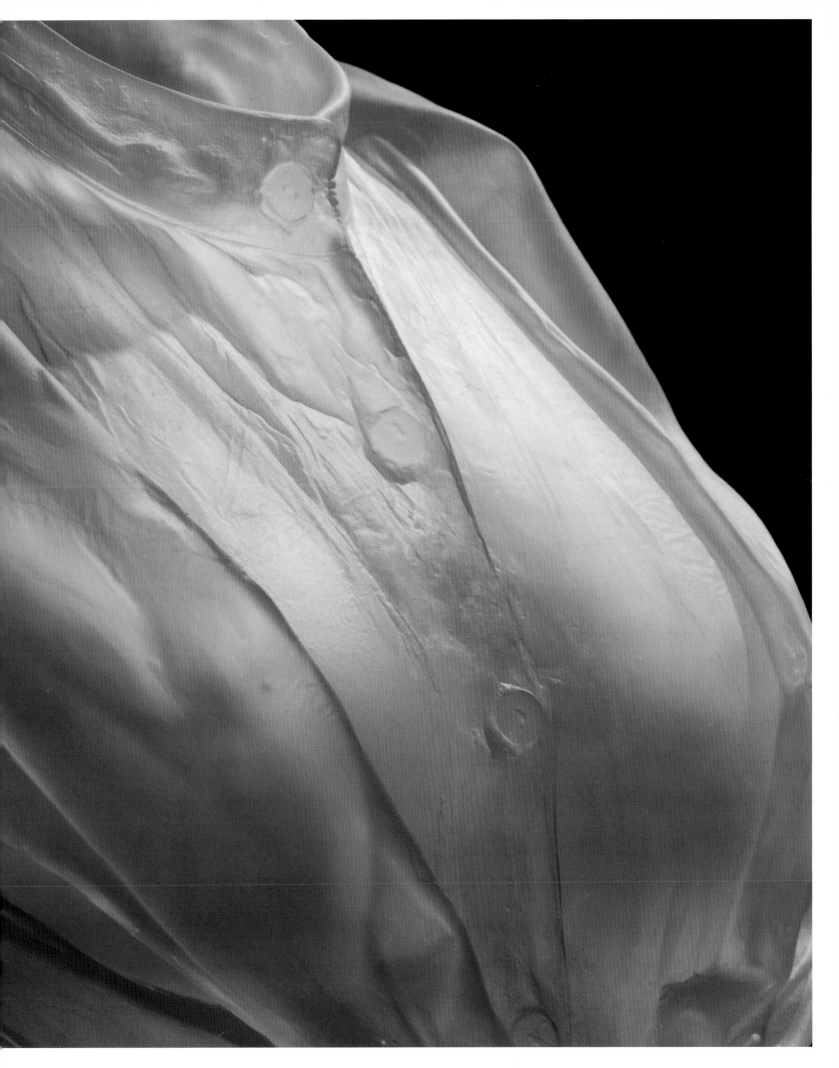

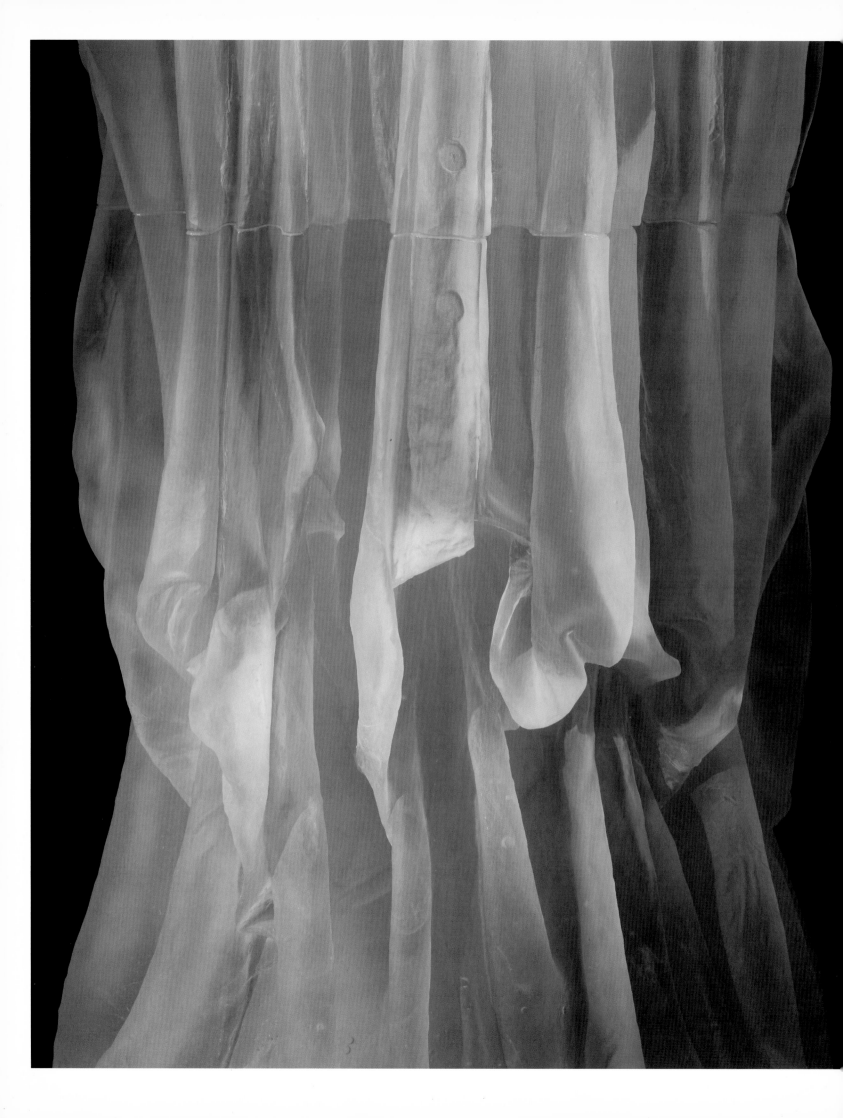

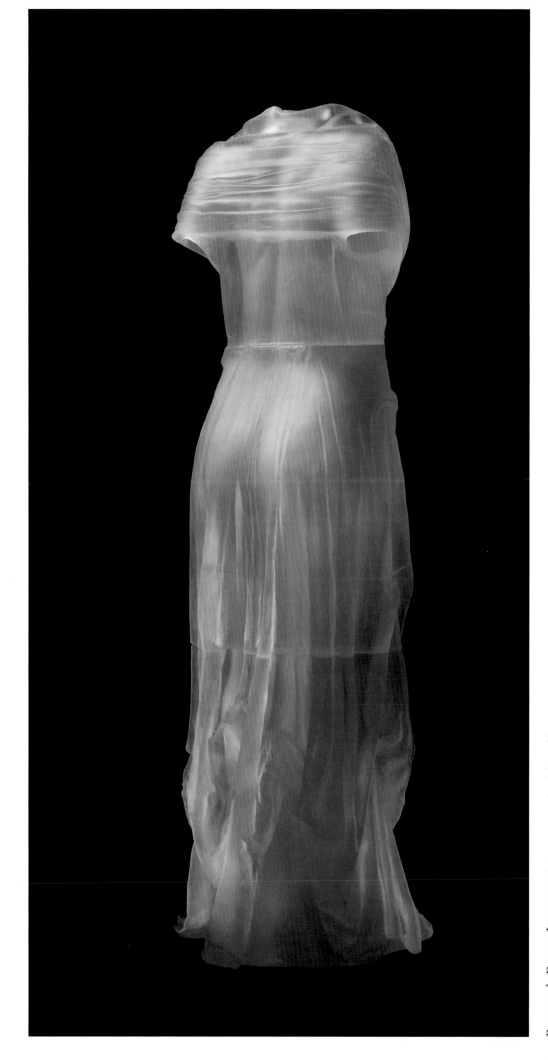

PIANIST'S DRESS IMPRESSION, 2005. 21¼ × 61¼ × 19¾ in.

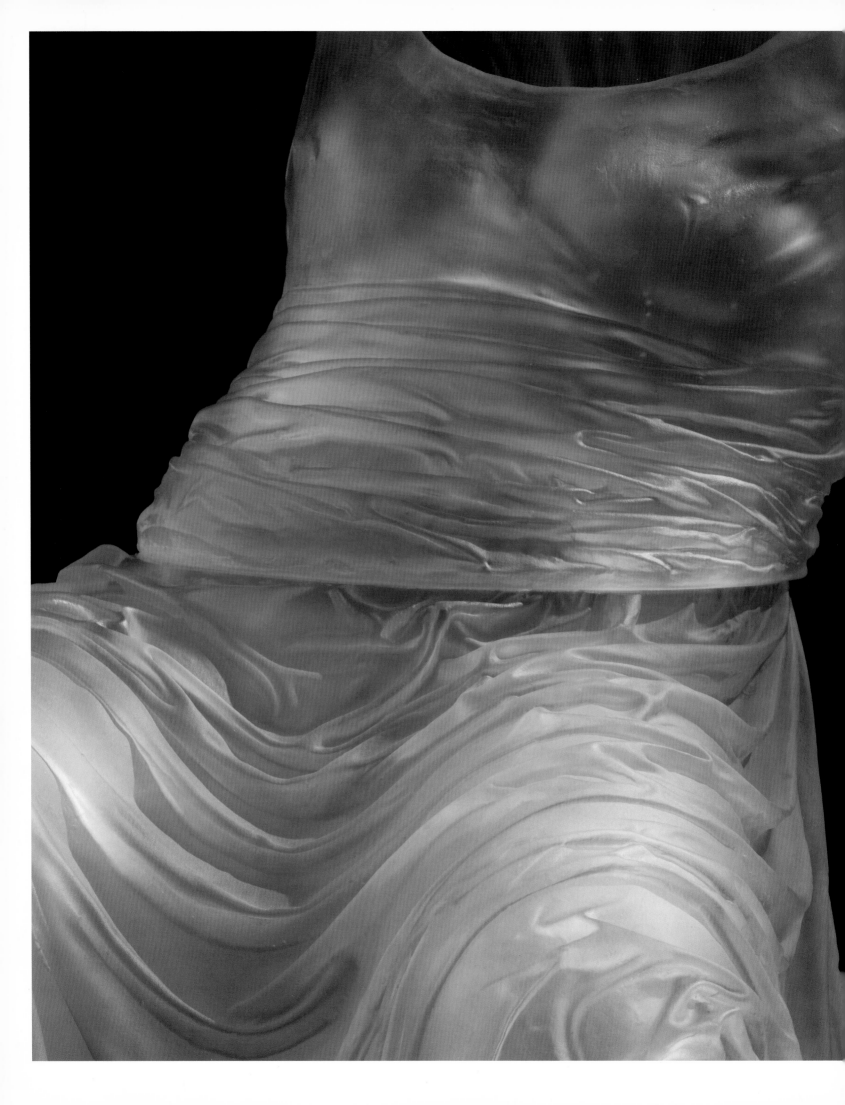

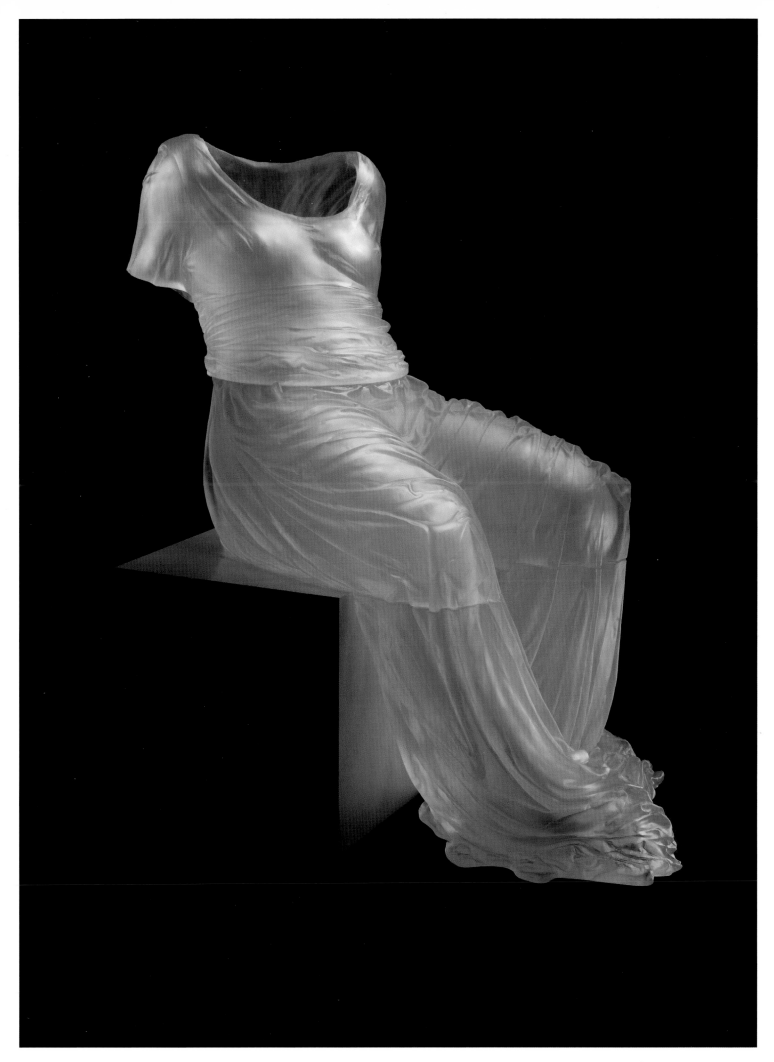

SEMI-RECLINING DRESS IMPRESSION, 2005. 50 × 28 × 42 ¼ in.

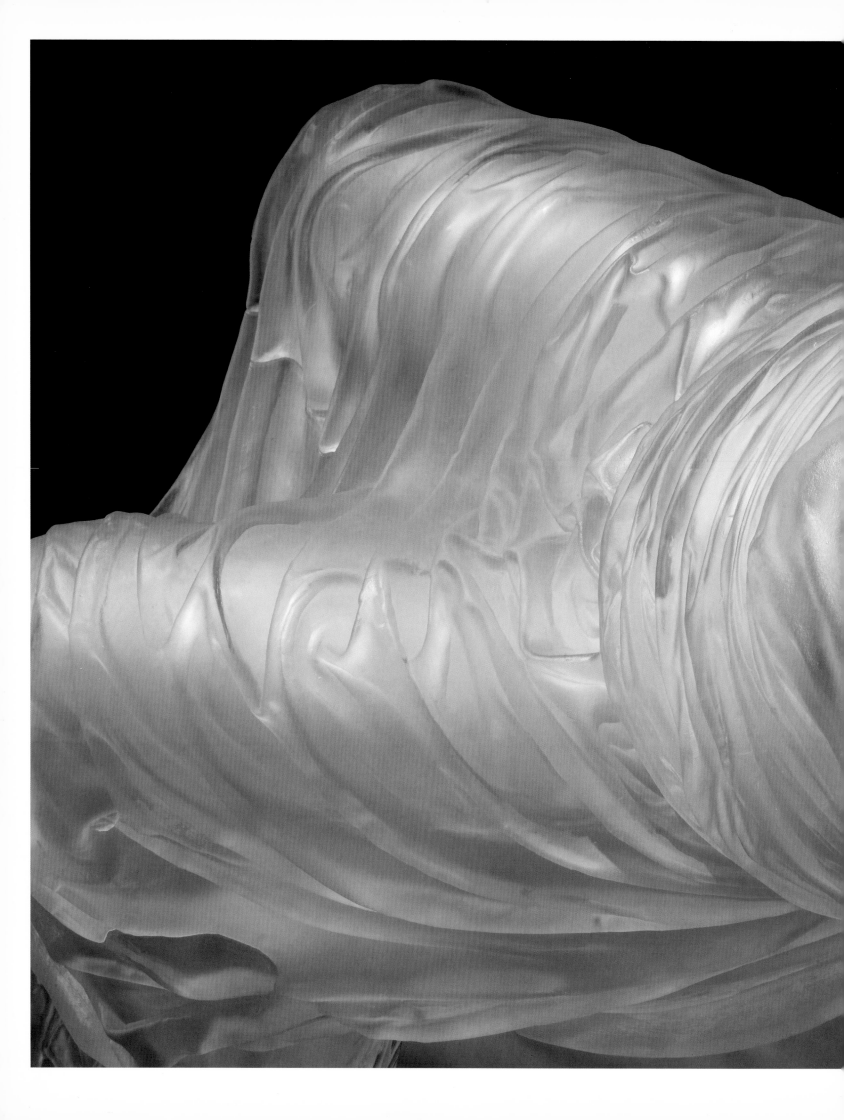

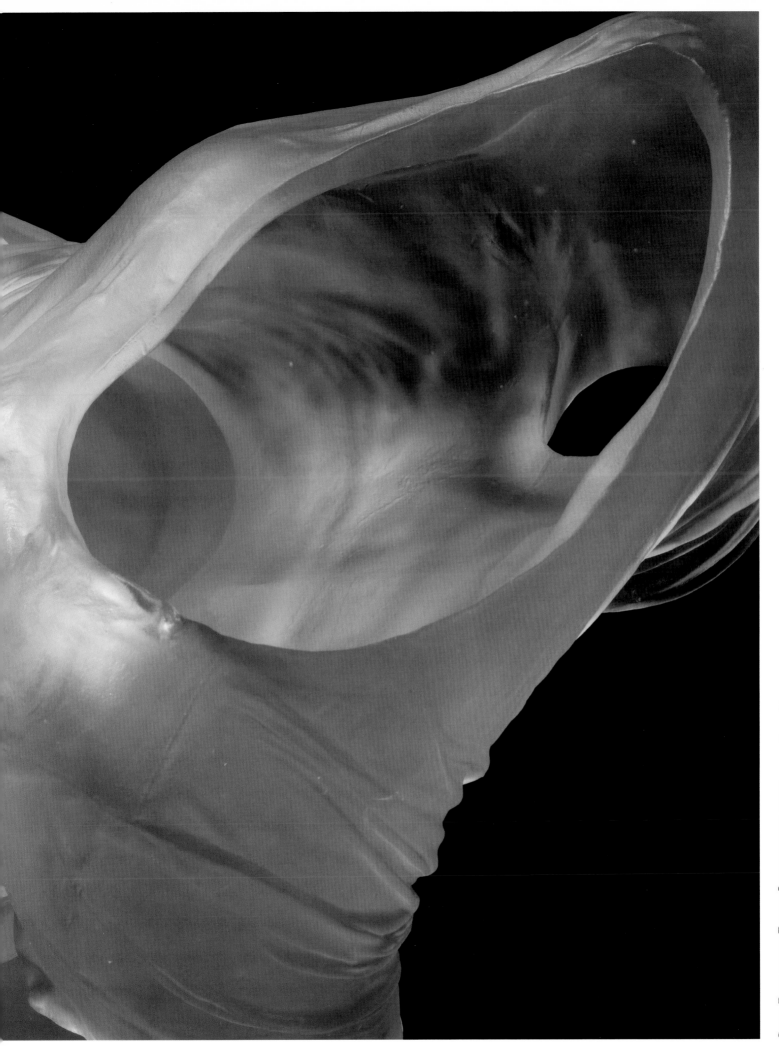

Semi-Reclining Dress Impression, 2005. 50 × 28 × 42 ¼ in.

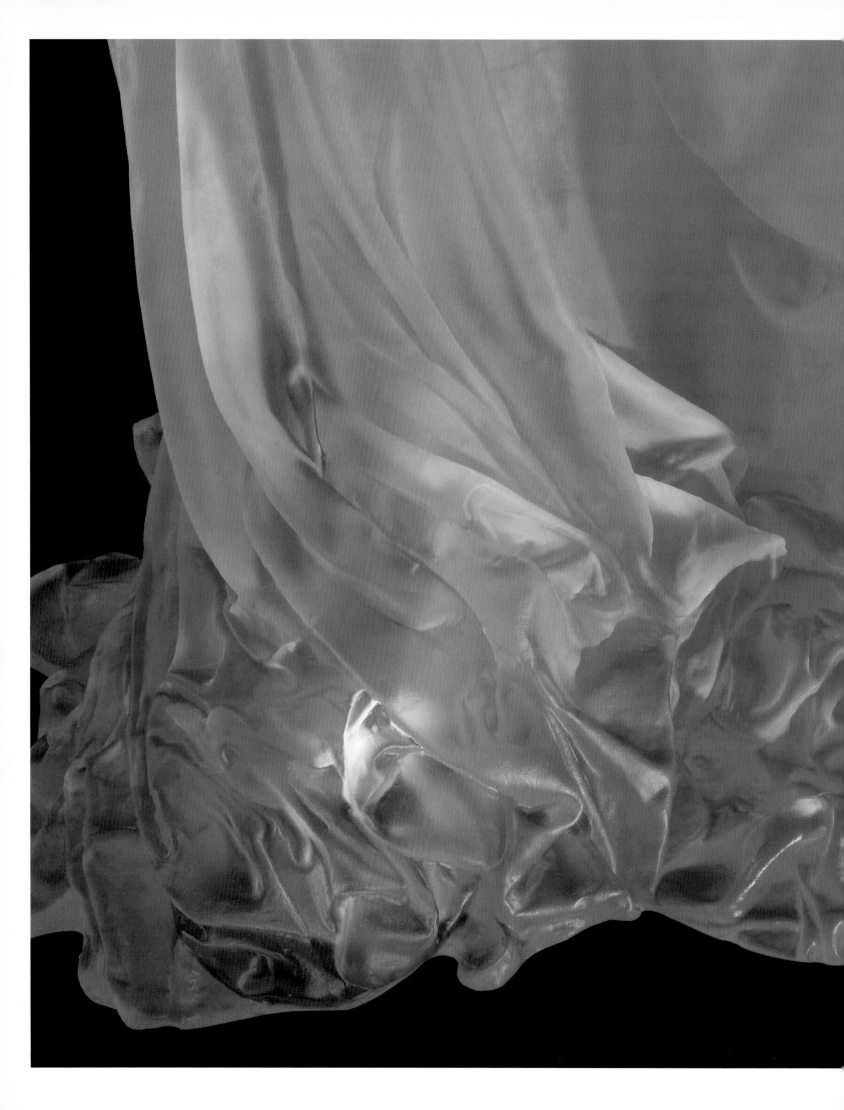

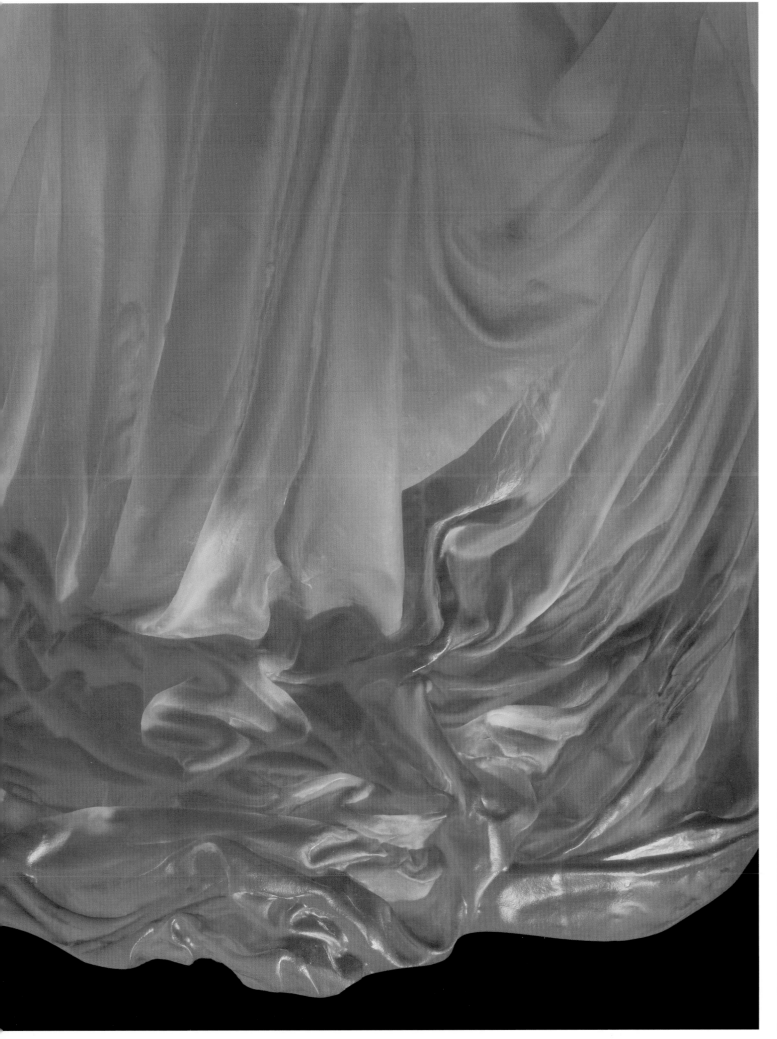

SEMI-RECLINING DRESS IMPRESSION, 2005. $50 \times 28 \times 42\frac{1}{2}$ in.

RECLINING DRAPERY IMPRESSION, 2005. 18 × 61½ × 22¾ in.

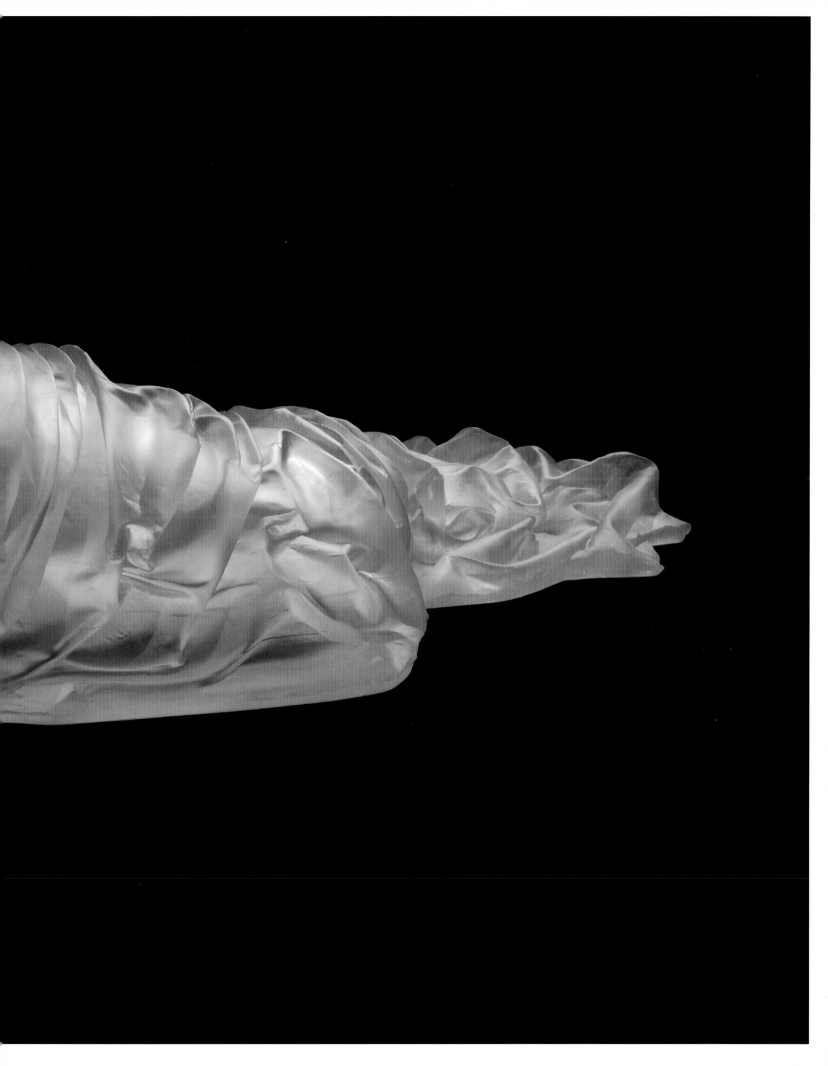

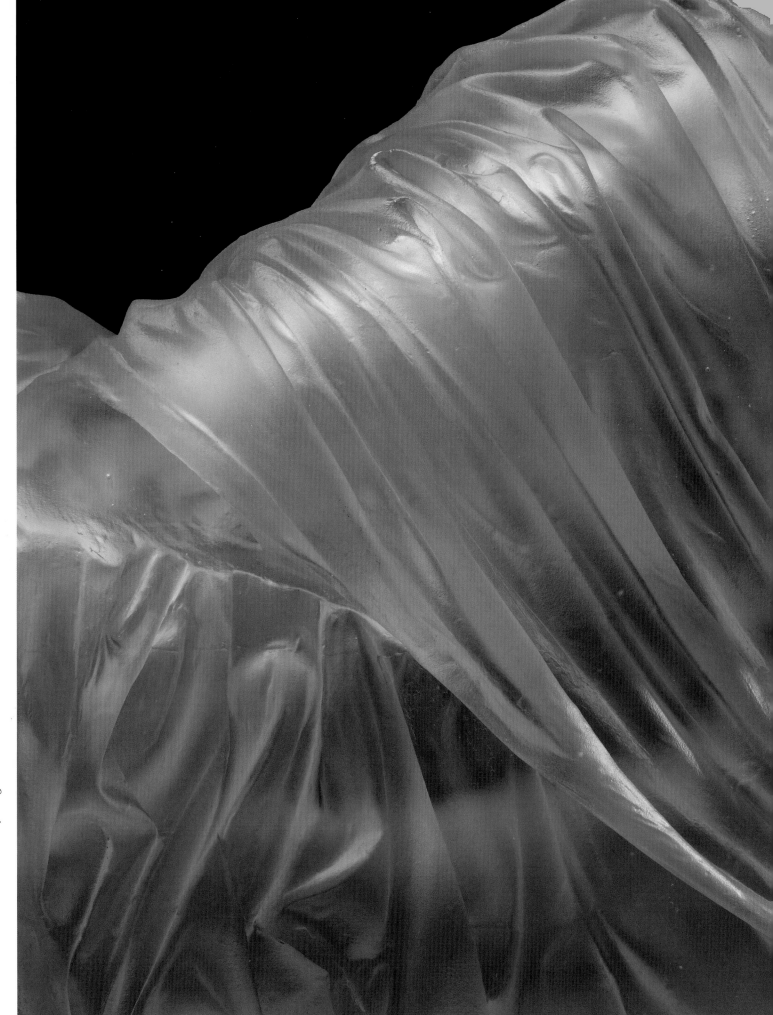

RECLINING DRAPERY IMPRESSION, 2005. 18 × 61¼ × 22¾ in.

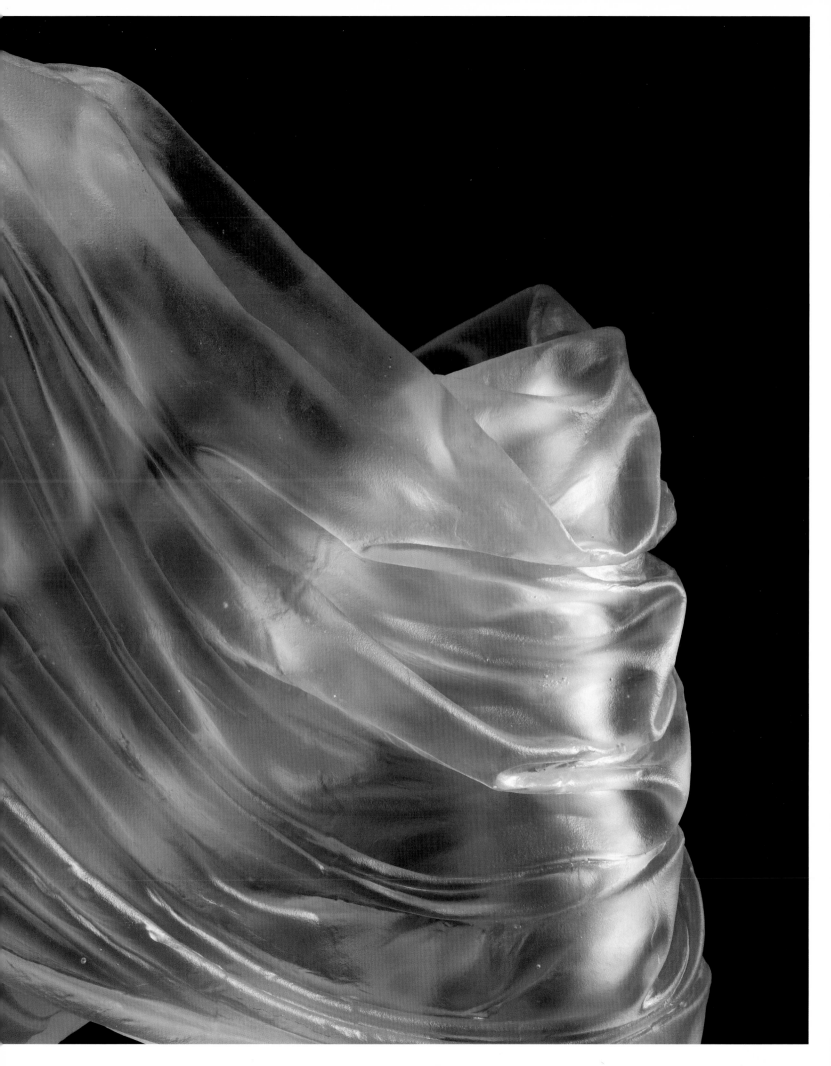

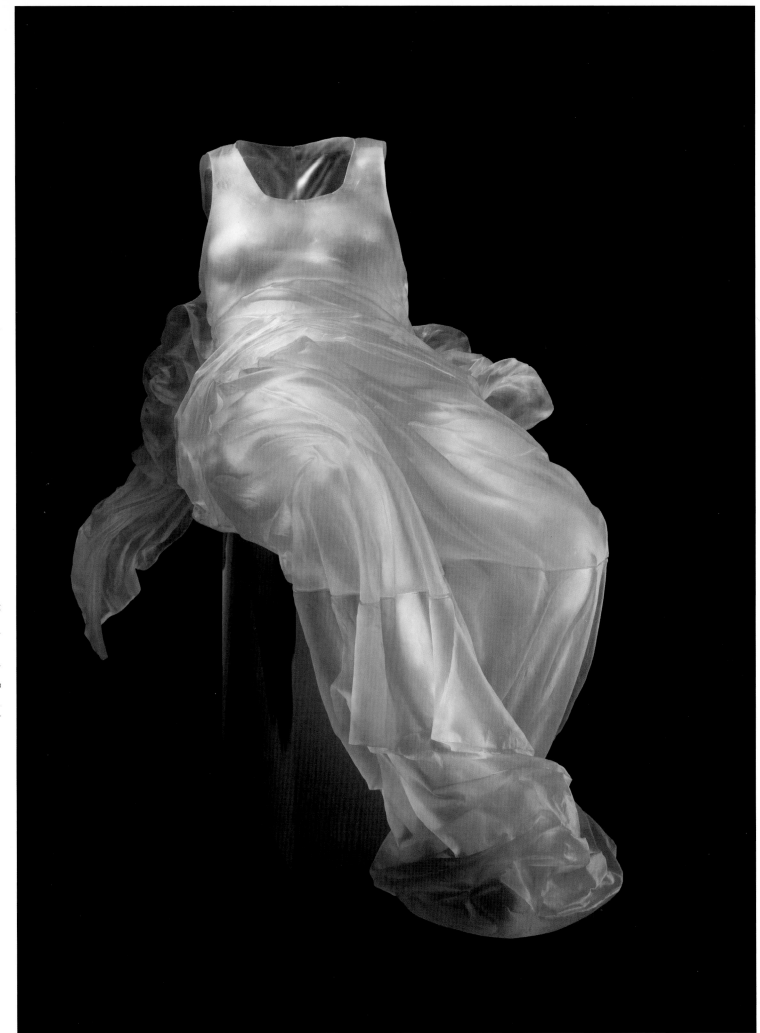

SEMI-RECLINING DRESS IMPRESSION WITH DRAPERY, 2005. 42 ½ × 27 ½ × 39 ¼ in.

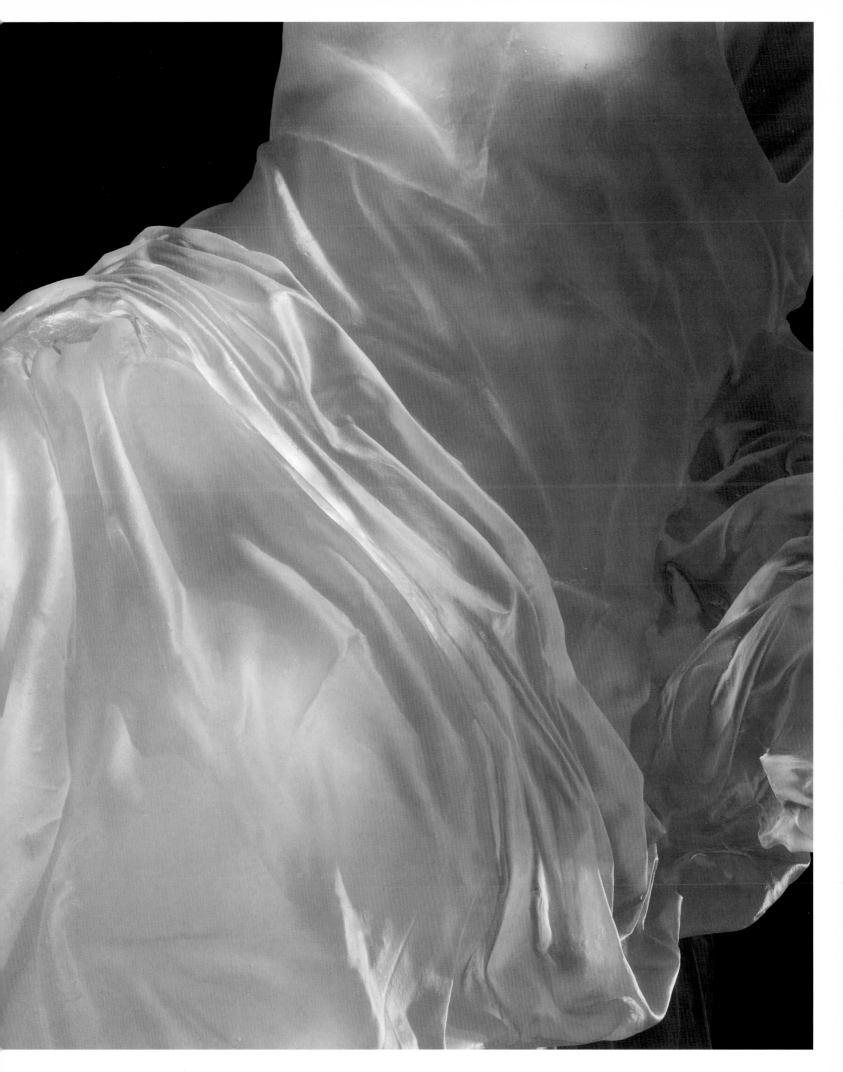

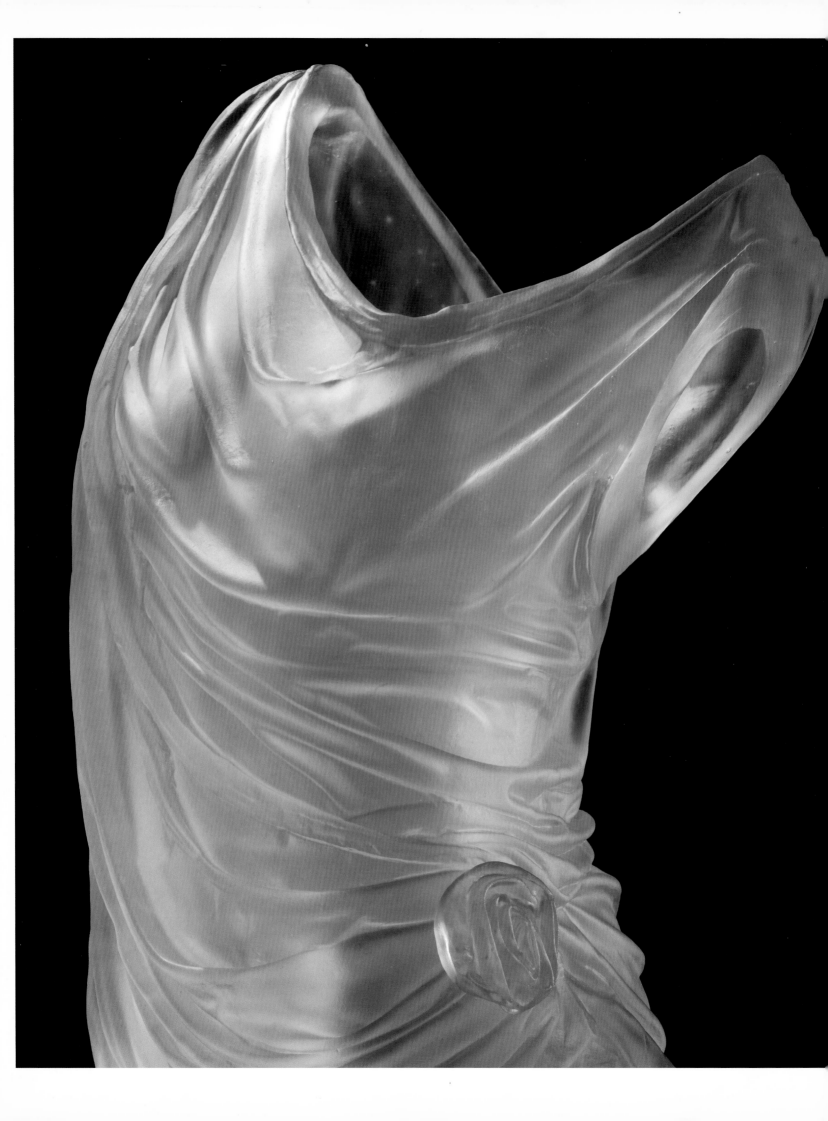

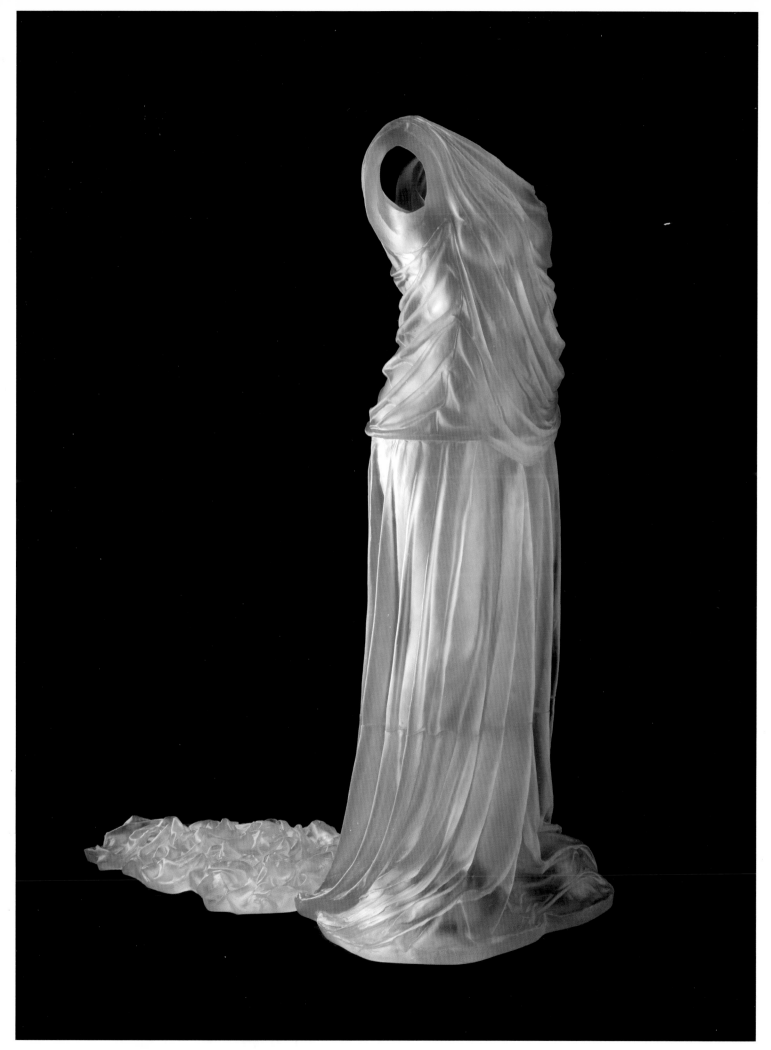

DRESS IMPRESSION WITH TRAIN, 2005. 58 ¼ × 22 ½ × 43 ¼ in.

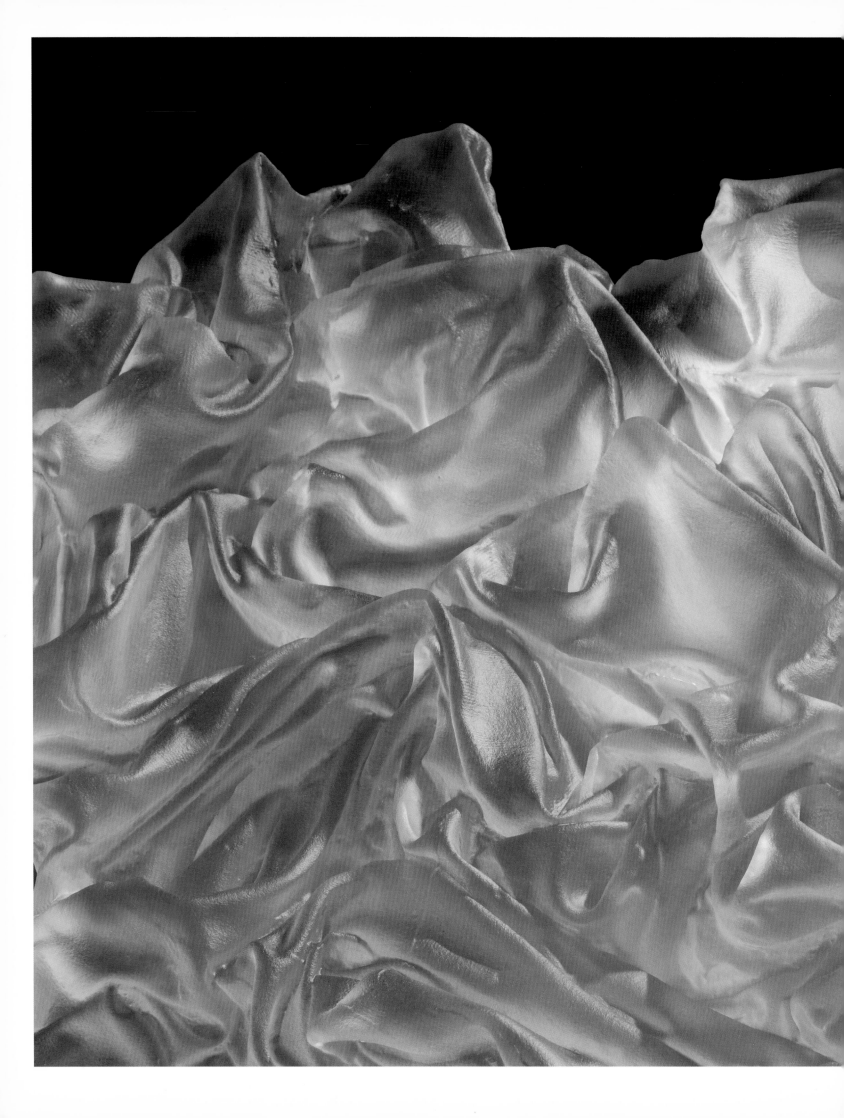

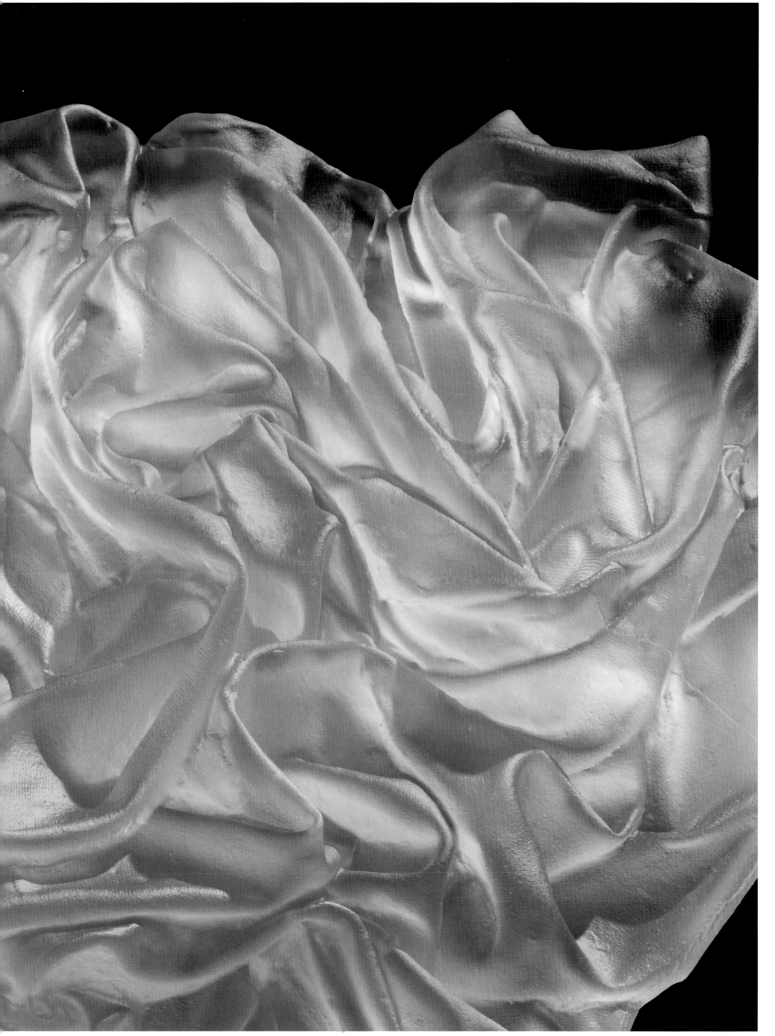

DRESS IMPRESSION WITH TRAIN, 2005. 58¼ × 22½ × 43¼ in.

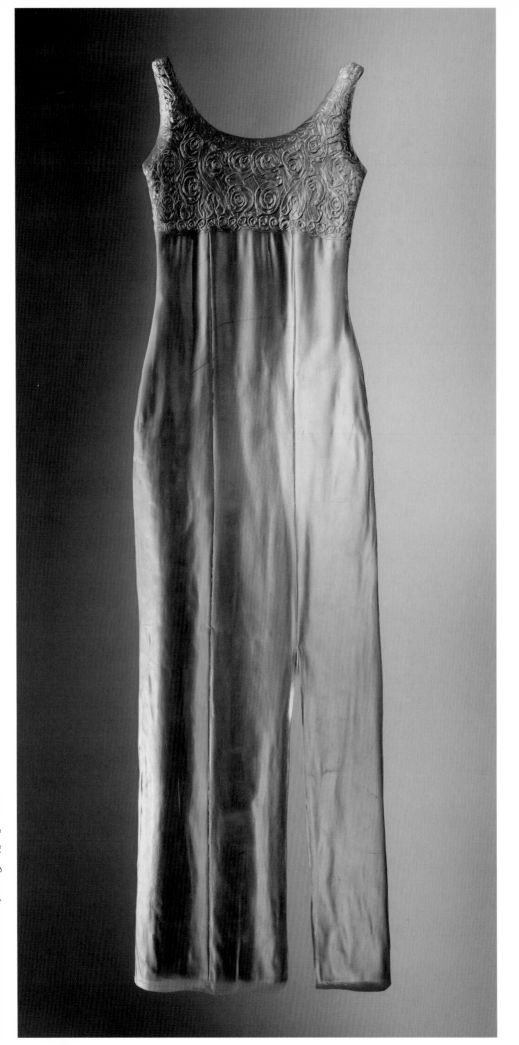

LACE DRESS REMNANT, 2005. 75 × 32 × 6 in.

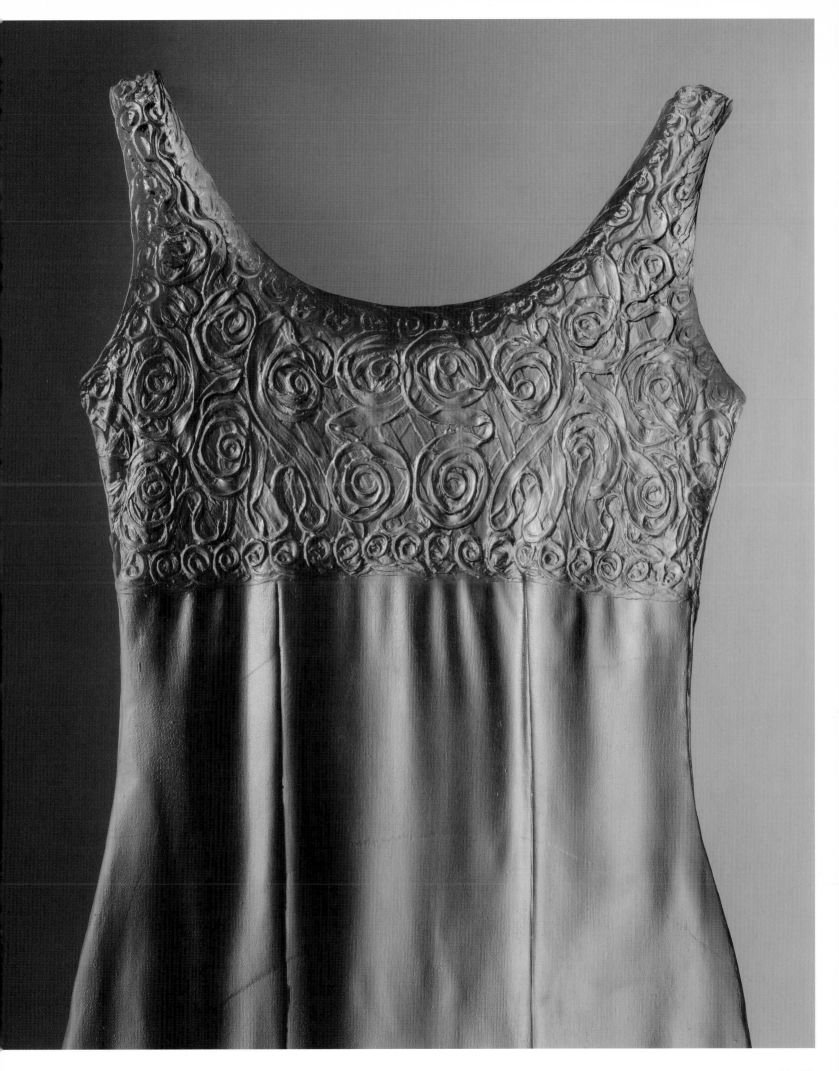

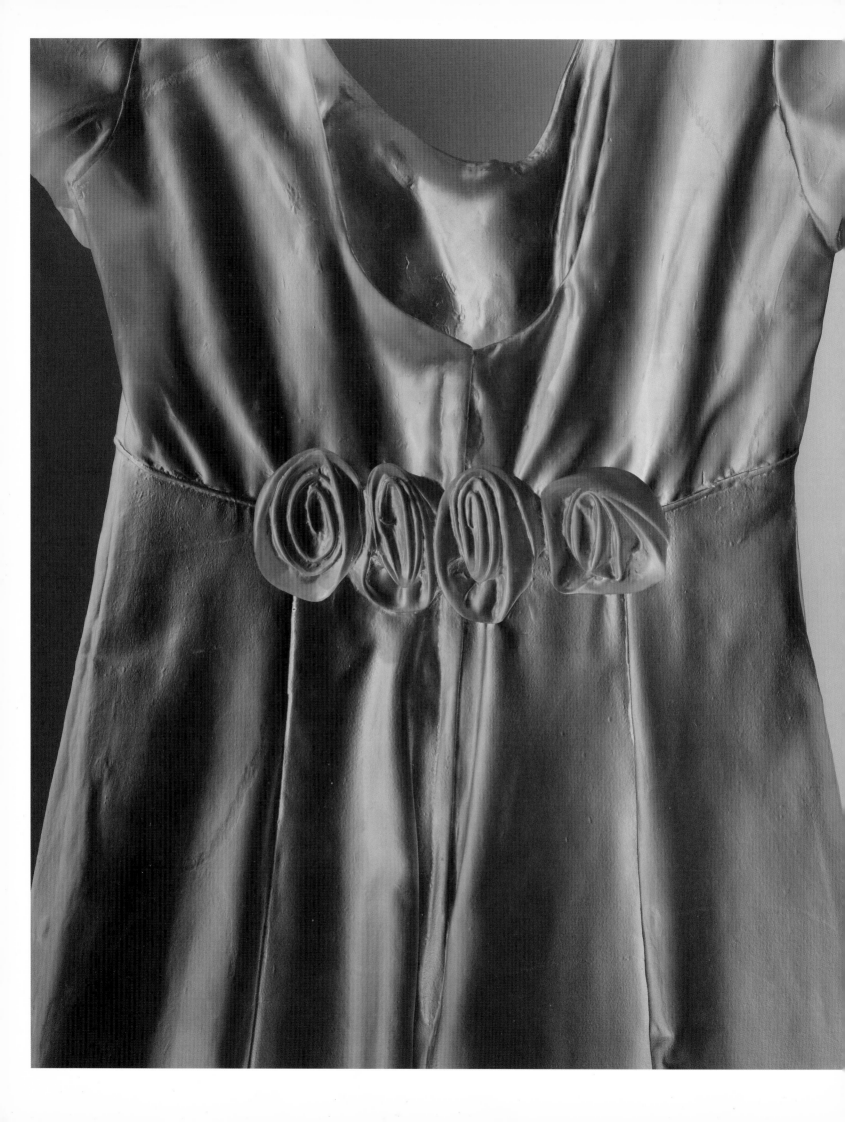

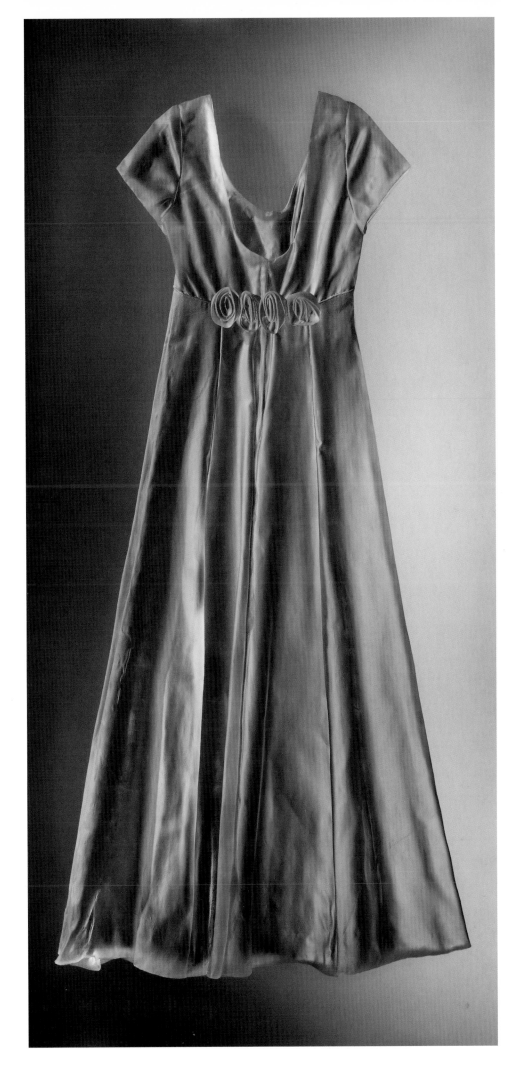

EVENING ROSE DRESS REMNANT, 2005. 75 × 32 × 6 in.

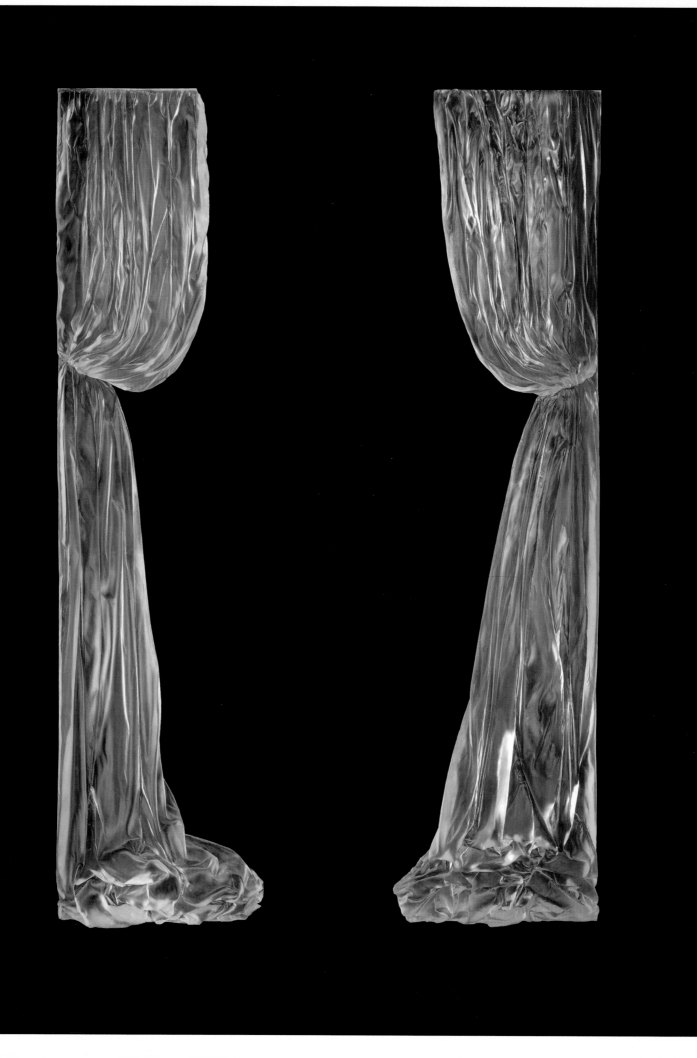

CURTAIN, 2005 92 × 24 × 6¼ in., each side. Installed width variable

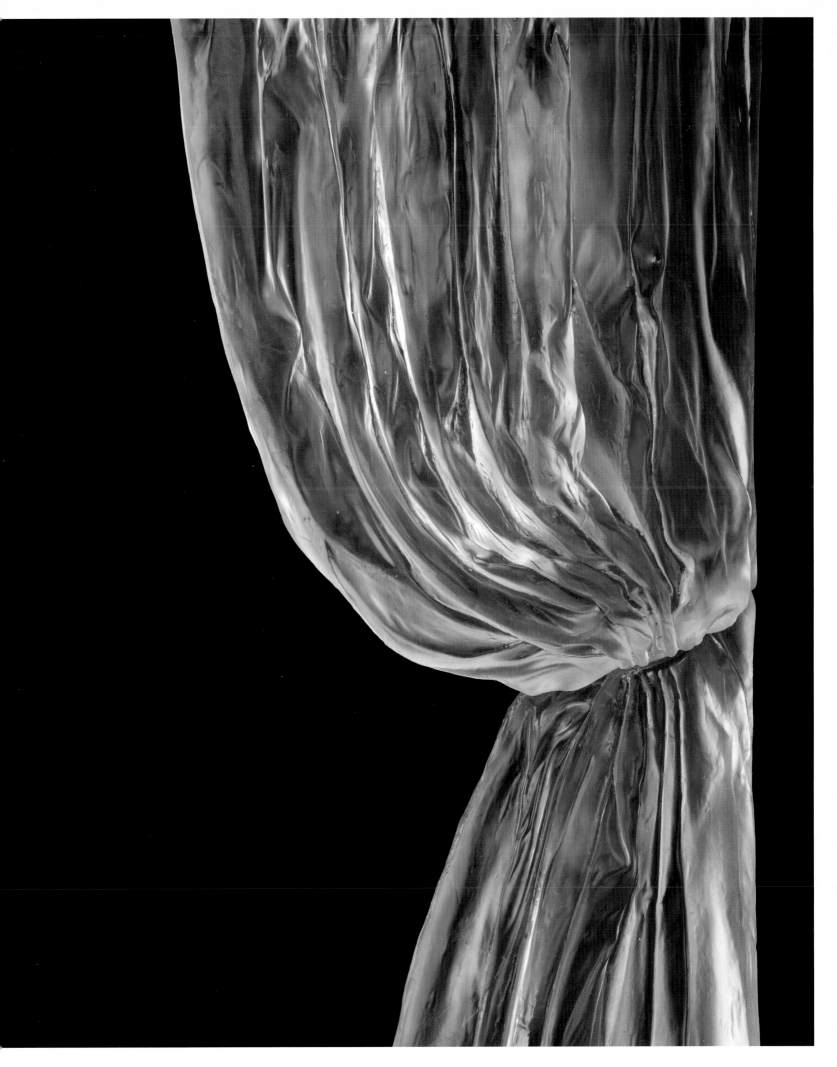

IMPRESSION 3, 2001. Sartoriotype, 69 × 43 in., sheet

IMPRESSION 5, 2001. Sartoriotype, 59 × 43 in., sheet

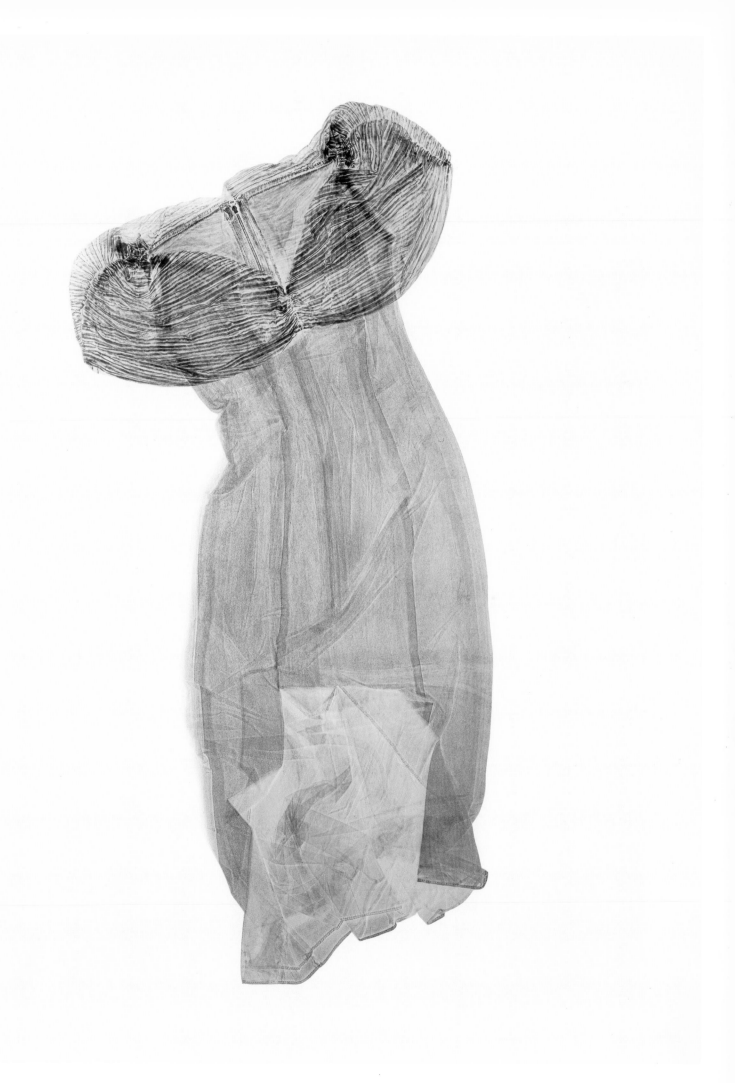

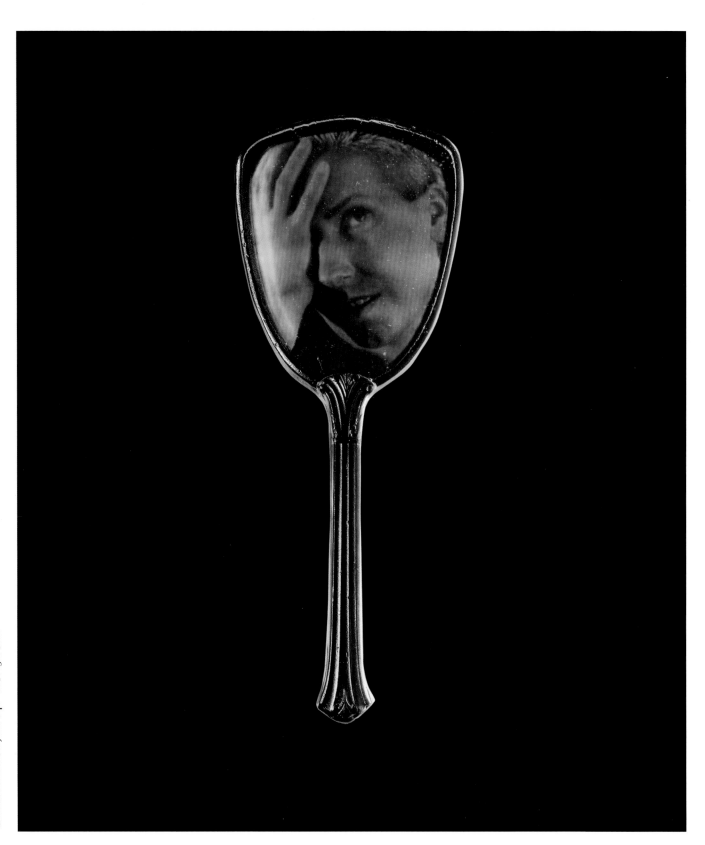

LARK MIRROR, 2004. 12½ × 5 × ½ in.

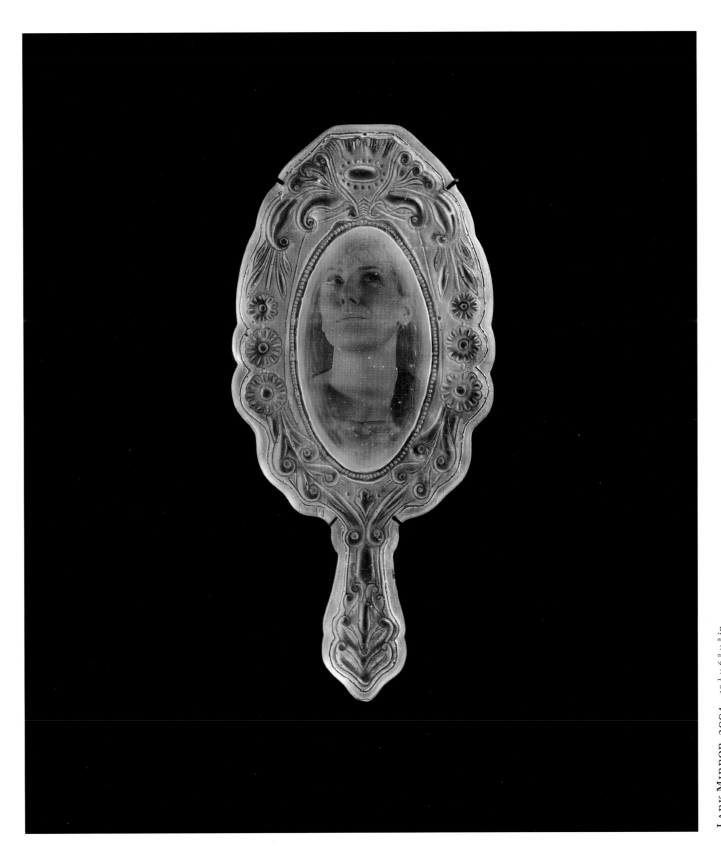

LARK MIRROR, 2004. 10½ × 6¾ × ¾ in.

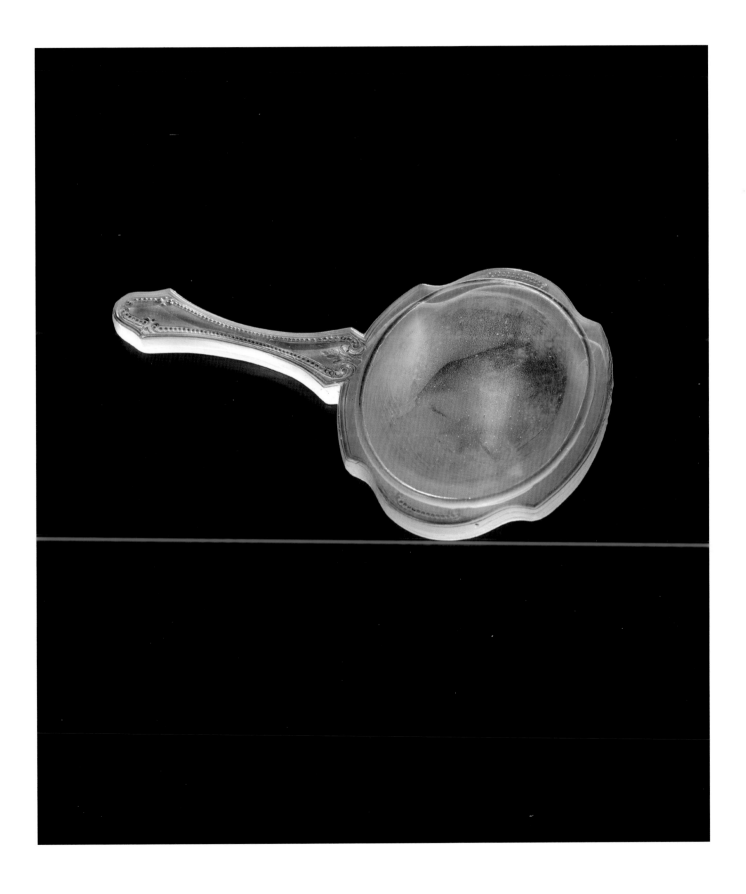

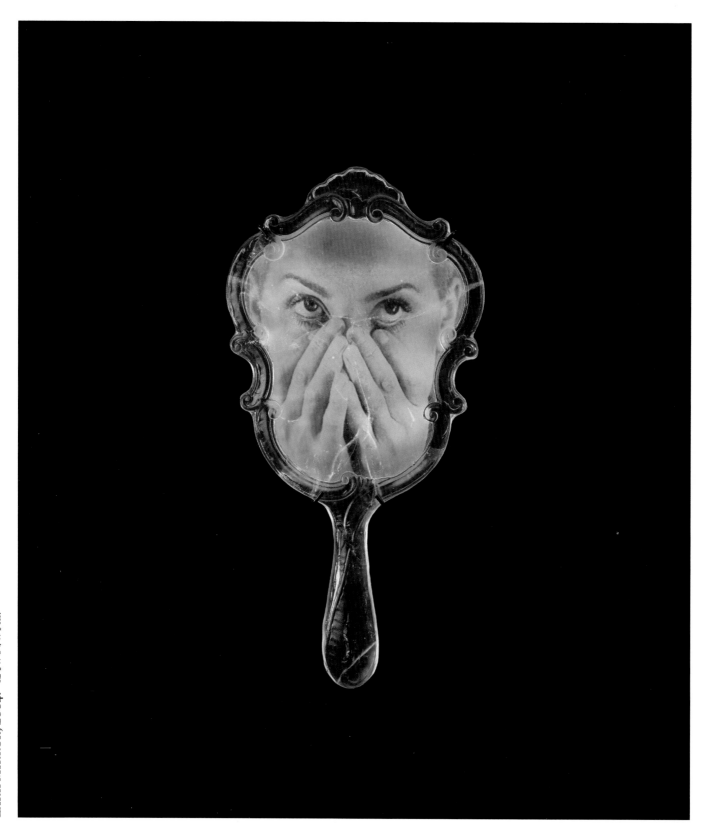

LARK MIRROR, 2004. $12\frac{1}{4} \times 6\frac{1}{4} \times \frac{1}{2}$ in.

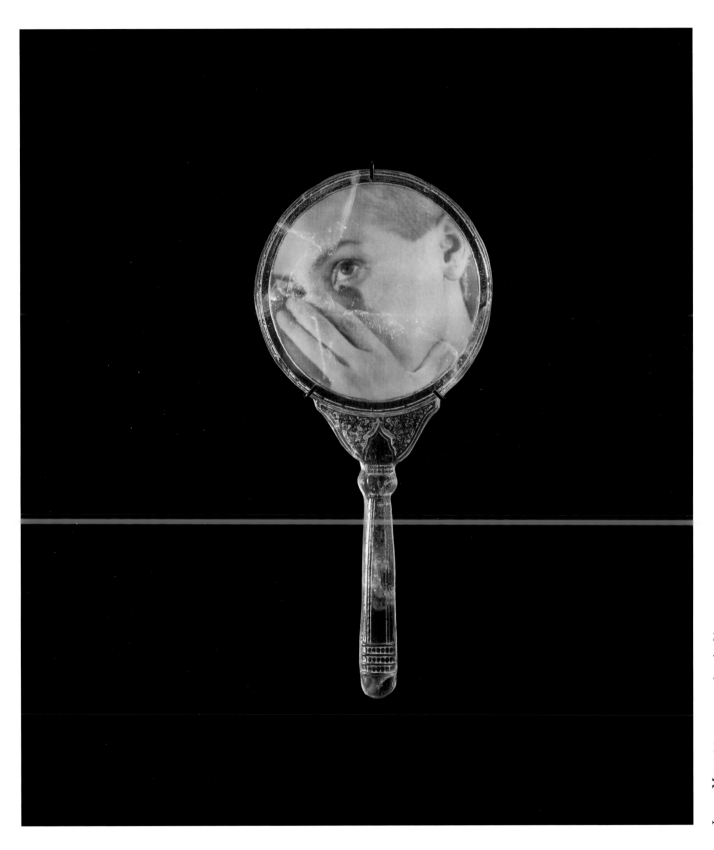

LARK MIRROR, 2004. $11\frac{1}{2} \times 5\frac{1}{4} \times \frac{3}{4}$ in.

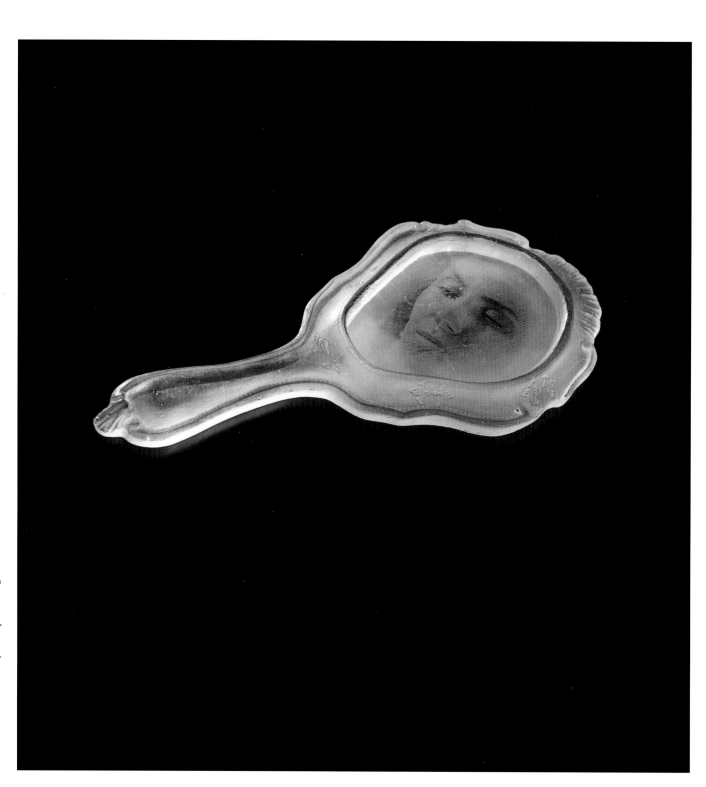

SLEEPING MIRROR, 2004. $11\frac{3}{4} \times 5\frac{1}{2} \times 1$ in.

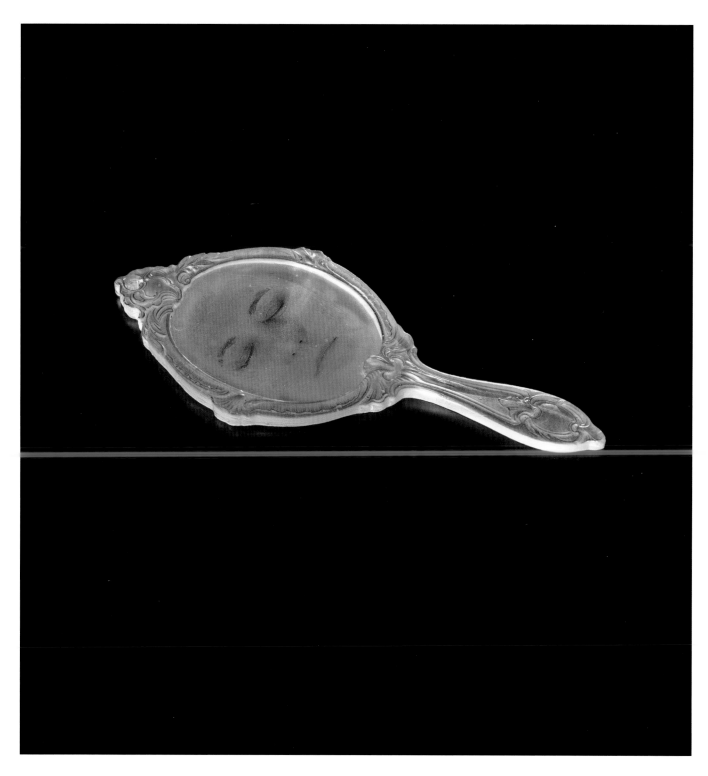

SLEEPING MIRROR, 2004. 11¼ × 5 × ½ in.

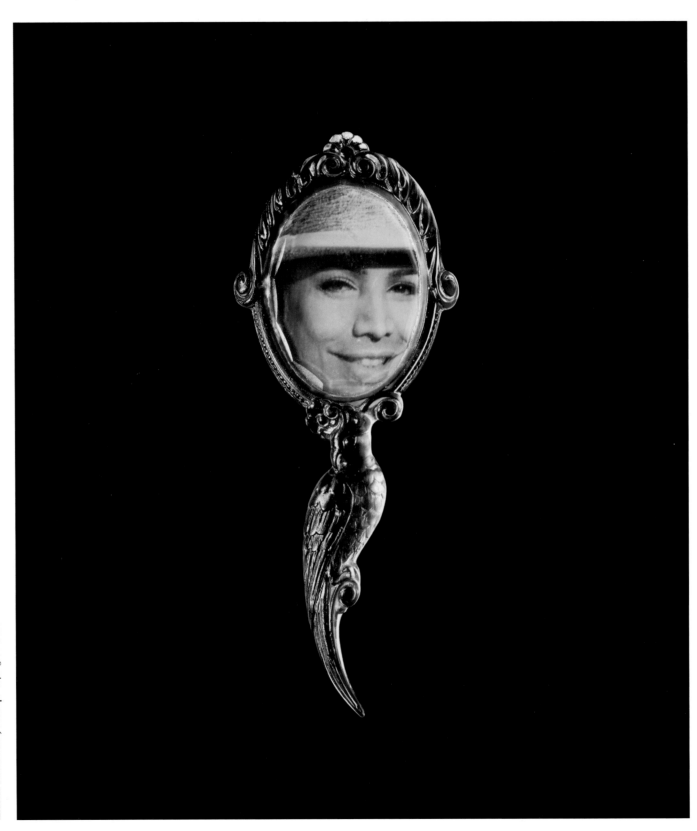

LARK MIRROR, 2004. 14 × 5 ¾ × ½ in.

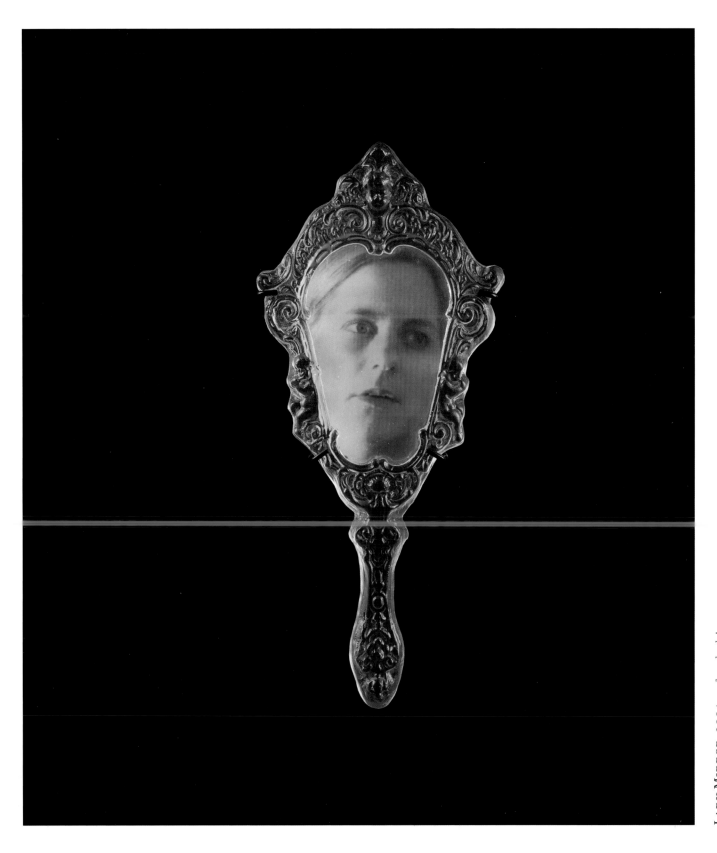

LARK MIRROR, 2004. 9¾ × 4½ × ½ in.

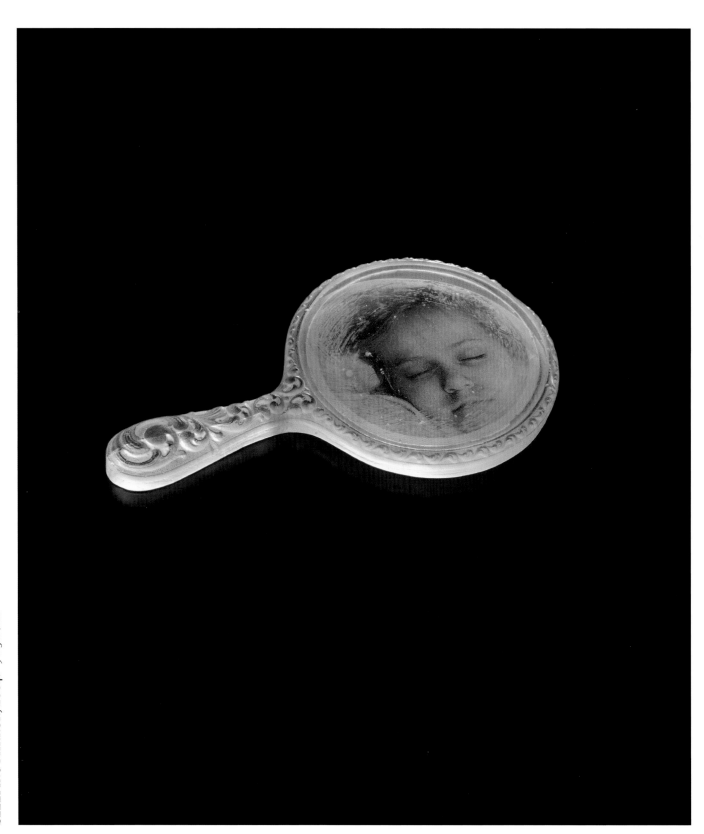

SLEEPING MIRROR, 2004. 9 × 5 × ¾ in.

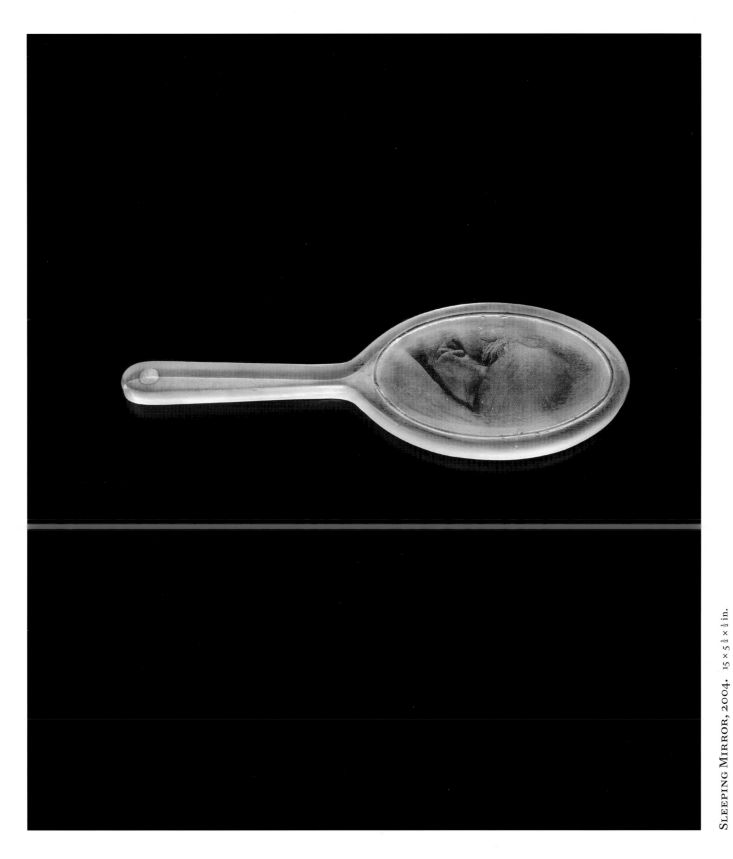

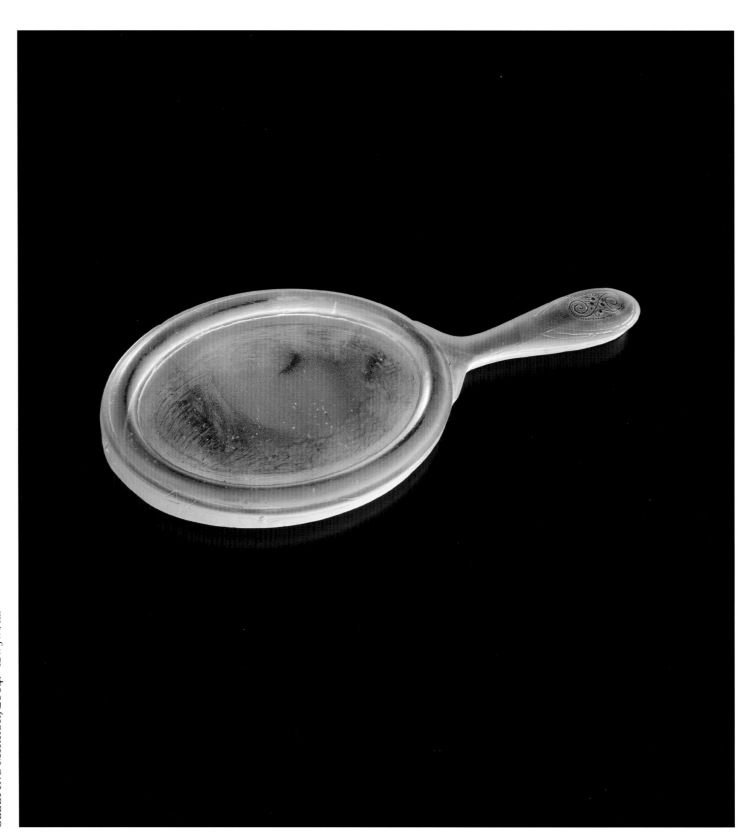

SLEEPING MIRROR, 2004. 12 × 5 × $\frac{3}{4}$ in.

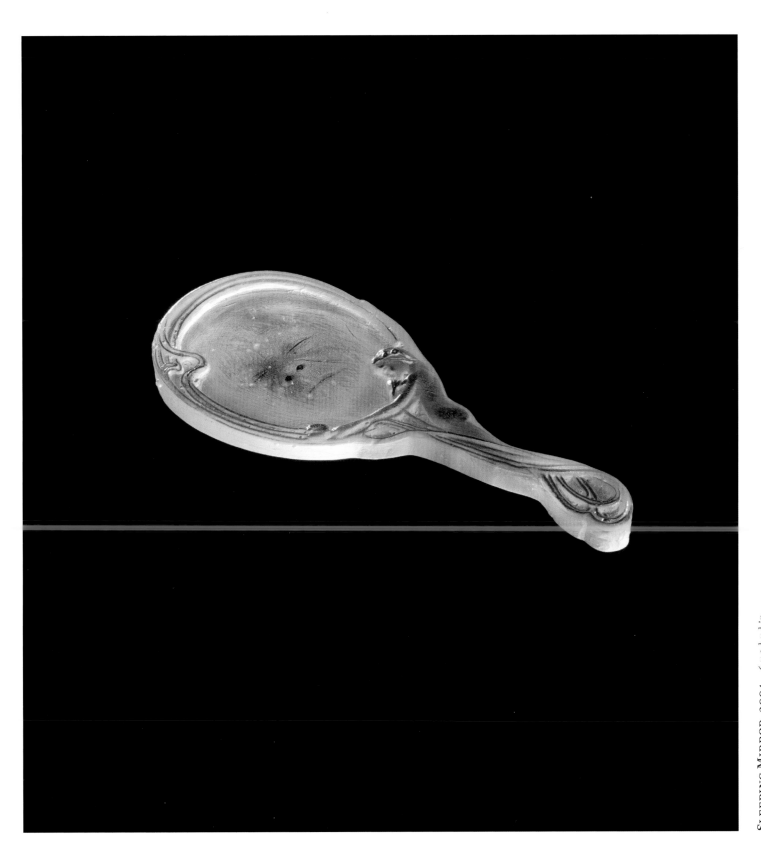

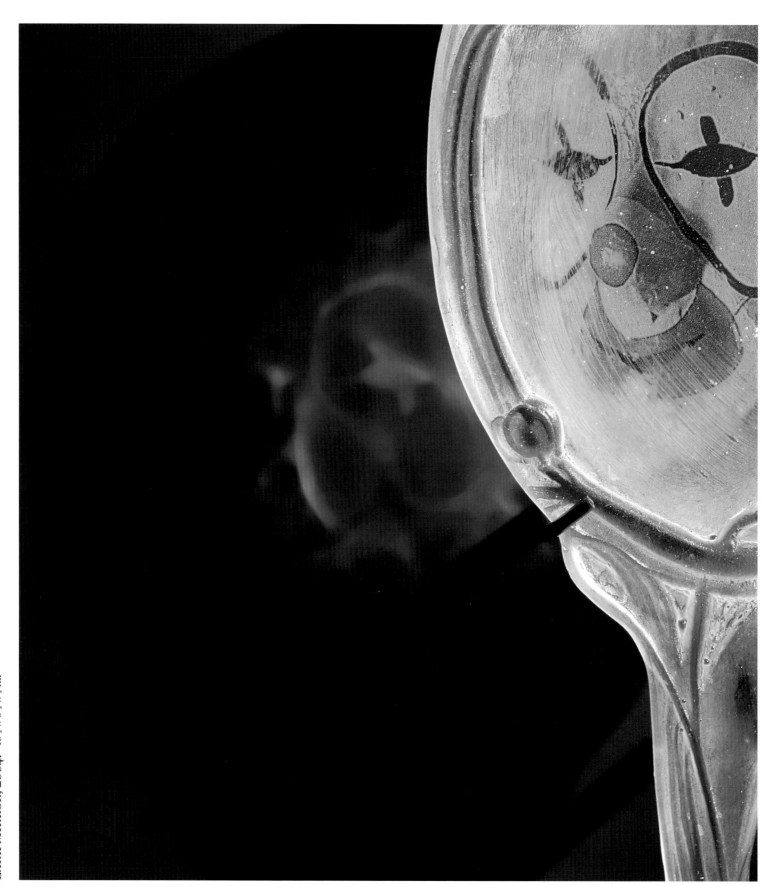

LARK MIRROR, 2004. $10\frac{1}{4} \times 6\frac{1}{2} \times \frac{1}{2}$ in.

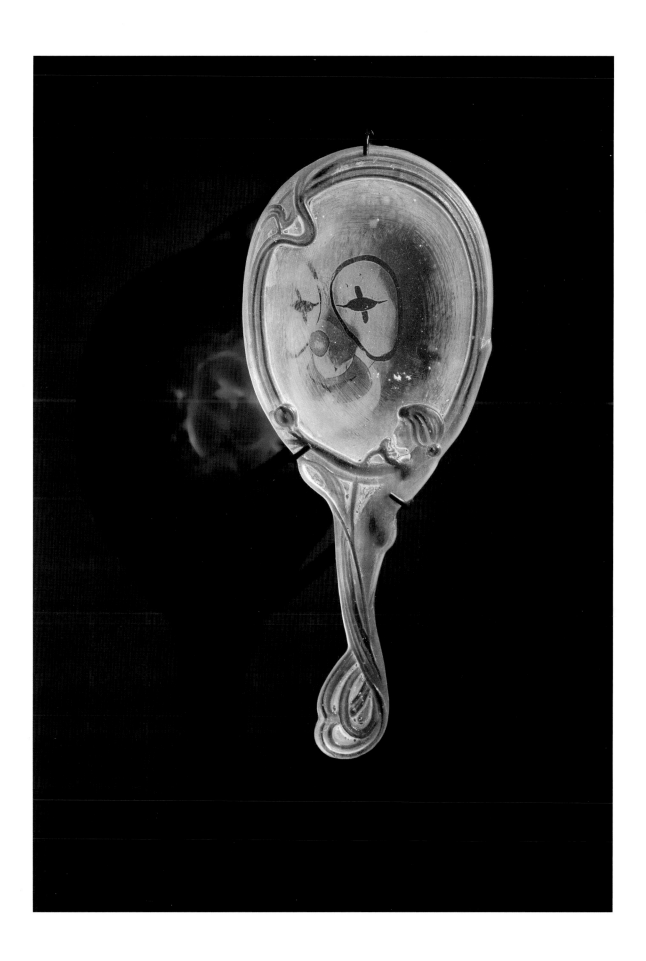

Karen LaMonte
Born in Manhattan, New York, 1967
Resides in Prague, Czech Republic and New York

EDUCATION
Academy of Art, Architecture & Design (UMPRUM), Prague, Czech Republic, 1999–2000
Rhode Island School of Design, Providence Rhode Island, BFA with Honors, 1990

Public Collections

National Gallery of Australia, Canberra, Australia
Fine Arts Museums of San Francisco, M. H. de Young Memorial Museum, the Saxe Collection
Tucson Museum of Art, Tucson, Arizona
Chrysler Museum of Art, Norfolk, Virginia
Charles A. Wustum Museum of Fine Arts, Racine, Wisconsin
Corning Museum, Corning, New York
Museum of American Glass, Millville, New Jersey

Grants and Awards

Japan–US Friendship Commission, National Endowment for the Arts, Creative Artists Exchange, 2006
The Virginia A. Groot Foundation, Recognition Award, 2005
UrbanGlass, Award for New Talent in Glass, 2002
Creative Glass Center of America, Fellowship, 2002 and 1991
The Louis Comfort Tiffany Foundation, Biennial Award, 2001
Fulbright Fellowship, Cast Glass Sculpture in the Czech Republic, 1999–2000
North Lands Creative Glass, Scotland, Residency July–September, 1999
Empire State Crafts Alliance, New Techniques Development Grant, 1992

Selected Museum Exhibitions

2005
Museum of Glass: International Center for Contemporary Art, Tacoma, WA.
 Absence Adorned. Solo exhibition. (exh. cat.)
Delaware Center for the Contemporary Arts, Wilmington, DE. *The Dress Makes the Woman*.
Moravian Gallery, Museum of Applied Arts, Brno, Czech Republic.
 X Years of Mold Melted Glass. (exh. cat.)
2004
Czech Museum of Fine Art, Prague, Czech Republic. *Vanitas*. Solo exhibition. (exh. cat.)
2003
Museum of Arts and Design, New York, NY. Museum fur Angewandte Kunst, Frankfurt, Germany.
 Corporeal Identity / Body Language. (exh. cat.)
Camerino Municipal Salon, Camerino, Italy. *Stanze di Vetro*. (exh. cat.)
Museum of American Glass, Millville, NJ. *20/20 Vision*. (exh. cat.)
Kent State University, Kent, OH. *Material in the Service of Form*.
2002
The Bevilacqua La Masa Foundation, Venice, Italy. *Glass Rooms*. (exh. cat.)
The University Museum, Iowa State University, Ames, Iowa. *Human Form*.
2001
Ohio Craft Museum, Columbus, OH. *Reality Check: Representational Images in Unlikely Media*.
Cleveland Center for Contemporary Art, Cleveland, OH. *Threads of Vision: Toward a New Feminine Politics*.
2000
Tucson Museum of Art, Tucson, AZ. *Light on Glass*.
Charles A. Wustum Museum of Fine Arts, Racine, WI. *Who Knows Where or When:*
 Artists Interpret Geography & Time.
GlasMuseum, Frauenau, Germany. *Glass in Context*.
1999
Leigh Yawkey Woodson Art Museum, Wausau, WI. *¡Cálido! Contemporary Warm Glass*. (exh. cat.)
1998
Vysegrad Fortress, Hungary. *VIII International Hungarian Glass Art Symposium Show*.
Whatcom Museum of History and Art, Bellingham, WA. *¡Cálido! Contemporary Warm Glass*. (exh. cat.)
Charles A. Wustum Museum of Fine Arts, Racine, WI. *Dress Up! Artists Address Clothing and Self Adornment*.
1997
Tucson Museum of Art, Mississippi Museum of Art, and Houston Museum of Art.
 ¡Cálido! Contemporary Warm Glass. (exh. cat.)
1996
Islip Art Museum, NY. *Glass Art Now: Made in Brooklyn*.

SELECTED BIBLIOGRAPHY

Bell, Robert. "Karen LaMonte." *Atelier Journal*. July–September 2004.

Bell, Robert. "The Lady Vanishes." *Artonview*. The National Gallery of Australia, Canberra. Summer 2002, No. 32, pp. 23–24.

Chaloupkova, Hana. "Skleněný Štaník." *Dolce Vita*. July/August 2002.

Chambers, Karen S. "From New York." *World News*. December 1995. (in Japanese)

Dandignac, Pat. "Portfolio." *American Craft*. February–March 1996

"Desert: Karen LaMonte." *Reflex*. November 21, 2004.

Dewulf, Sophie-Lucie. "Interpretazioni materiche 1." *Mood. Moda Design*. Iss. 73/September 2004, p. 105.

Dolce Vita Magazine. Cover photo. March 2005.

Donohoe, Victoria. "Dresses, Not Always for Wearing." *Philadelphia Inquirer*. June 26, 2005, p. L13.

Dunleavy, Virginia. "A Clear View of Glass Art." *New York Newsday*. December 29, 1996.

Firth, Mike. "GAS from a Texas Viewpoint." Common Ground: *Glass*. Summer 1997.

Frantz, Susanne. "20/20 Vision." *American Craft*. December 2003/January 2004, p. 48.

Fronczak, Rogers Mimi. "Vestiges and Visages." *Prague Post*. January 12–18, 2005, p. B19

Galloway, Anne. "Firehouse Gallery Exhibit Expresses the Fine Art of Glass." *Times Argus* (Rutland, VT). July 2, 2004.

"Glass Menagerie." *The New Yorker*. January 1994.

Glueck, Grace. "Celebrating the Flesh: Its Fullness, Its Frailties, Its Forbidden Secrets." *New York Times*. December 5, 2003.

Greenwood, Phoebe. "They've Got Views." *The London Times*. January 7, 2004. Sec T2, pp. 10–11.

Harrison, Helen. "Glass Art Now: Made in Brooklyn." *New York Times*. January 5, 1997

Hart, Marla. "Glass Theater." *Chicago Tribune*. April 12, 1996.

Hawkins, Margaret. "Believe the Hype." *Chicago Sun Times*. April 12, 1996.

Hill, Lori. Dress Makes the Woman exhibition review. *City Paper* (Philadelphia). June 30–July 6, 2005.

Jerome, Sara. "The Places We Remember." *American Style*. April 2005, pp. 22–26.

Kim, Hyun-Jung. (Review) *Crart* (Korean art magazine). No. 15, November 2002.

Kingsley, April. "Preview: Warm Is Hot." *Glass*. No. 66, Spring 1997.

Kohler, Lucartha. *Women Working in Glass*. Atglen, PA: Schiffer Publishing, 2003.

LaMonte, Karen. "Global Glass: Czech Republic." *Glass*. No. 75, Summer 1999.

Lebow, Edward. "¡Cálido! Some Like It Warm." *American Craft*. Vol. 57, No. 5, October/November 1997.

Littman, Brett. "The Spectacular Glass Dresses of Karen LaMonte." *Glass*. No. 86, Spring 2002.

Lovelace, Carey. "Glass Art's Double Edge." *New York Newsday*. December 27, 1996.

Milne, V. "Women of NY: Three Young Artists Who Wrestle with Ideas in Their Work." *Glass*. No. 61, Winter 1995.

Netsky, Ron. "Shattering Preconceptions about Glass." *City Paper* (Rochester, NY). June 7, 2001.

New Glass Review 23. Juried publication by Neues Glas and The Corning Museum of Glass, May 2002.

Oldknow, Tina. "Collectors as Advocates." *American Craft*. Vol. 62, No. 3, June/July 2002.

Perreault, John. "Portfolio: Cast Glass, Hot and Warm." *Glass*. No. 75, Summer 1999.

Perreault, John. "Reflections on Glass." *American Craft*. June/July 2005, cover and pp. 42–45.

Regan, Margaret. "Review: Best and Brightest." *Tucson Weekly*. May 1997.

Rice, Robin. "Karen LaMonte." Creative Glass Center of America Resident Fellows: Essays. On line at www.wheatonvillage.org/creativeglasscenteramerica/criticresidency/robinrice/lamontekaren (2002).

Rice, Robin. Arts Commentary, The Pennsylvania Council on the Arts, Fellowship Recipients. Harrisburg, 2003, p. 63.

Schmölders, Wolfgang. "Faltenwurf in Glas (Drapes in Glass)." *Glashaus Magazine*. April 2000.

"Seventh Annual Gathering of Glass." *Glass Art*. January/February 2000.

Stepan, Petr. "Karen LaMonte." *Keramica a Sklo January*. 2005. Iss 1. pp. 28–29

"Ten Years of Cast Glass" (exhibition review). *Art and Antiques*. April 2005, p. 92.

Thorsen, Eve. "Fragile Perfection." *Burlington Free Press* (Vermont). July 1, 2004, p. 6.

Van der Burght, Angela. "Stand." *This Side Up!* No. 11, Autumn 2000.

Vanitas exhibition review. *Skylines Austrian Air*. December 2005, p. 36.

Vanitas exhibition review. *Atelier Journal*. January 2005.

Vanitas exhibition review. *CSA Inflight Magazine*. January/February 2005, p. 64.

"Vidrio de Alta Costura." *Vidro Plano*. No. 70, January 2002.

Waddington, Chris. "Glass Houses: Show Looks into Artists' Souls." *Times-Picayune* (New Orleans). March 17, 1995.

Waggoner, Shawn. "The Marvelous in the Mundane: Karen LaMonte." *Glass Art*. Vol. 17, No. 4, 2002, pp. 5–6.

Yelle, Richard. *Contemporary Art From UrbanGlass*. Atglen, PA: Schiffer Publishing, 2000.

Yelle, Richard. *International Glass Art*. Atglen, PA: Schiffer Publishing, 2003.

"Zrcadlení: Reflected." *Dolce Vita*. (*Vanitas* exhibition review). Issue 5, 2004, p. 24.

Plate List

pages 24, 26
Reclining Dress Impression, 2005
Cast glass
20 × 63 ½ × 15 ¾ in. (51 × 161 × 40 cm)
Photographer: Gabriel Urbánek

pages 28, 29, 30, 31
**Seated Dress Impression
with Drapery**, 2005
Cast glass
48 ½ × 29 ½ × 26 ¾ in. (123 × 75 × 68 cm)
Photographer: Martin Polák

pages 32, 33
Dress Impression with Drapery, 2005
Cast glass
55 × 37 ¾ × 17 ¼ in. (140 × 96 × 44 cm)
Photographer: Martin Polák

pages 34, 35, 36, 37
Pianist's Dress Impression, 2005
Cast glass
21 ¼ × 61 ½ × 19 ¾ in. (54 × 156 × 50 cm)
Photographer: Martin Polák

pages 38, 39, 40, 42, and 10
Semi-Reclining Dress Impression, 2005
Cast glass
50 × 28 × 42 ½ in. (104 × 71 × 108 cm)
Photographer: Martin Polák

pages 44, 46, back cover
Reclining Drapery Impression, 2005
Cast glass
18 × 61 ½ × 22 ¾ in. (46 × 156 × 58 cm)
Photographer: Martin Polák

pages 48, 49, front cover
**Semi-Reclining Dress Impression
with Drapery**, 2005
Cast glass
42 ½ × 27 ½ × 39 ¼ in. (108 × 70 × 100 cm)
Photographer: Martin Polák

pages 50, 51, 52
Dress Impression with Train, 2005
Cast glass
58 ¼ × 22 ½ × 43 ¼ in. (148 × 57 × 110 cm)
Photographer: Martin Polák

pages 54, 55
Lace Dress Remnant, 2005
Cast glass, plate glass, steel
75 × 32 × 6 in. (190 × 80 × 15 cm)
Photographer: Martin Polák

pages 56, 57
Evening Rose Dress Remnant, 2005
Cast glass, plate glass, steel
75 × 32 × 6 in. (190 × 80 × 15 cm)
Photographer: Martin Polák

pages 58, 59
Curtain, 2005
Cast glass, steel
92 × 24 × 6 ½ in. (232 × 59 × 16 cm), each side
Installed width variable
Photographer: Martin Polák

page 61
Impression 3, 2001
Sartoriotype
69 × 43 in. (175 × 109 cm), sheet
Photographer: Martin Polák

pages 62, 63
Impression 4, 2001
Sartoriotype
59 × 43 in. (150 × 109 cm), sheet
Photographer: Martin Polák

page 65
Impression 5, 2001
Sartoriotype
59 × 43 in. (150 × 109 cm), sheet
Photographer: Martin Polák

page 66
Lark Mirror (G4), 2004
Cast glass, steel, photo etching
Glass 12 ½ × 5 × ½ in. (31.5 × 12.5 × 1 cm)
Mounting plate 20 ½ × 15 in. (52 × 38 cm)
Photographer: Martin Polák

page 67
Lark Mirror (P1), 2004
Cast glass, steel, photo etching
Glass 10 ½ × 6 ¾ × ¾ in. (26.5 × 17 × 2 cm)
Mounting plate 20 ½ × 15 in. (52 × 38 cm)
Photographer: Martin Polák

pages 68, 69
SLEEPING MIRROR (N1), 2004
Cast glass, steel, photo etching
Glass 10 ½ × 6 ½ × ½ in. (27 × 16.5 × 1.5 cm)
Mounting plate 20 ½ × 15 in. (52 × 38 cm)
Photographer: Martin Polák

page 70
LARK MIRROR (A2), 2004
Cast glass, steel, photo etching
Glass 12 ½ × 6 ¼ × ½ in. (31.5 × 16 × 1.5 cm)
Mounting plate 20 ½ × 15 in. (52 × 38 cm)
Photographer: Martin Polák

page 71
LARK MIRROR (E5), 2004
Cast glass, steel, photo etching
Glass 11 ½ × 5 ¼ × ¾ in. (29 × 13.5 × 2 cm)
Mounting plate 20 ½ × 15 in. (52 × 38 cm)
Photographer: Martin Polák

page 72
SLEEPING MIRROR (Q1), 2004
Cast glass, steel, photo etching
Glass 11 ¾ × 5 ½ × 1 in. (30 × 14 × 2.5 cm)
Mounting plate 20 ½ × 15 in. (52 × 38 cm)
Photographer: Martin Polák

page 73
SLEEPING MIRROR (J1), 2004
Cast glass, steel, photo etching
Glass 11 ½ × 5 × ½ in. (29.5 × 13 × 1 cm)
Mounting plate 20 ½ × 15 in. (52 × 38 cm)
Photographer: Martin Polák

page 74
LARK MIRROR (D1), 2004
Cast glass, steel, photo etching
Glass 14 × 5 ¾ × ½ in. (35.5 × 14.5 × 1.5 cm)
Mounting plate 20 ½ × 15 in. (52 × 38 cm)
Photographer: Martin Polák

page 75
LARK MIRROR (B2), 2004
Cast glass, steel, photo etching
Glass 9 ¾ × 4 ½ × ½ in. (25 × 12 × 1 cm)
Mounting plate 20 ½ × 15 in. (52 × 38 cm)
Photographer: Martin Polák

page 76
SLEEPING MIRROR (R1), 2004
Cast glass, steel, photo etching
Glass 9 × 5 × ¾ in. (23 × 13 × 2 cm)
Mounting plate 20 ½ × 15 in. (52 × 38 cm)
Photographer: Martin Polák

page 77
SLEEPING MIRROR (U1), 2004
Cast glass, steel, photo etching
Glass 15 × 5 ½ × ½ in. (38 × 14 × 1.5 cm)
Mounting plate 20 ½ × 15 in. (52 × 38 cm)
Photographer: Martin Polák

page 78
SLEEPING MIRROR (T1), 2004
Cast glass, steel, photo etching
Glass 12 × 5 × ¾ in. (30 × 13 × 2 cm)
Mounting plate 20 ½ × 15 in. (52 × 38 cm)
Photographer: Martin Polák

page 79
SLEEPING MIRROR (M1), 2004
Cast glass, steel, photo etching
Glass 6 × 2 ½ × ½ in. (16 × 7 × 1 cm)
Mounting plate 20 ½ × 15 in. (52 × 38 cm)
Photographer: Martin Polák

pages 80, 81
LARK MIRROR (O1), 2004
Cast glass, steel, photo etching
Glass 10 ½ × 6 ½ × ½ in. (27 × 16.5 × 1.5 cm)
Mounting plate 20 ½ × 15 in. (52 × 38 cm)
Photographer: Martin Polák